LANDSCAPE BEYOND

David Ward

ARGENTUM

First published 2008 by Argentum,
an imprint of Aurum Press Ltd
7 Greenland Street, London NW1 0ND

A catalogue record for this book is available from the British
Library.

ISBN 978 1 902538 51 8

6	5	4	3	2	1
2013	2012	2011	2010	2009	2008

Designed by Eddie Ephraums

Printed in China

Opposite: **Hof Church**
Iceland

Overleaf: **Mesquite Dunes, Death Valley**
California

A JOURNEY INTO PHOTOGRAPHY

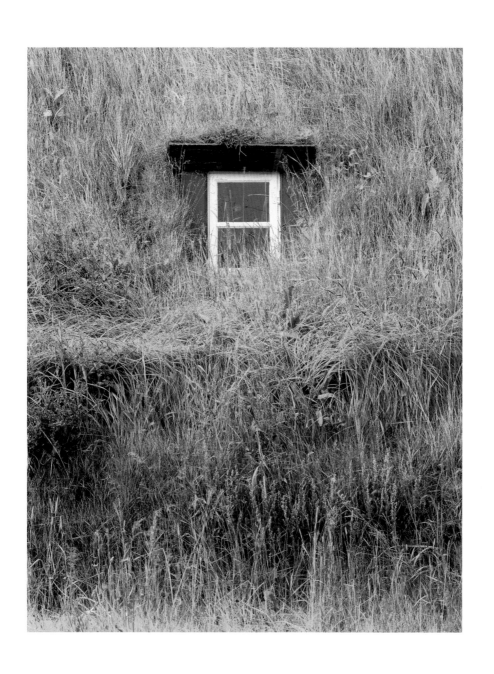

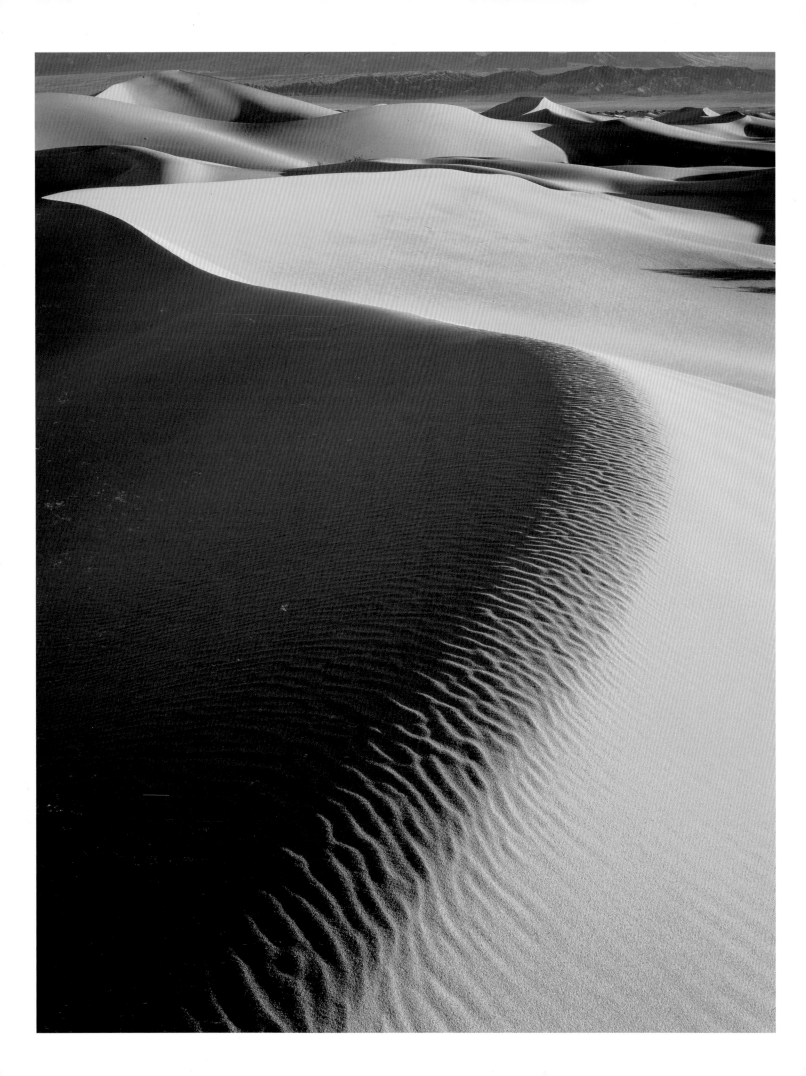

CONTENTS

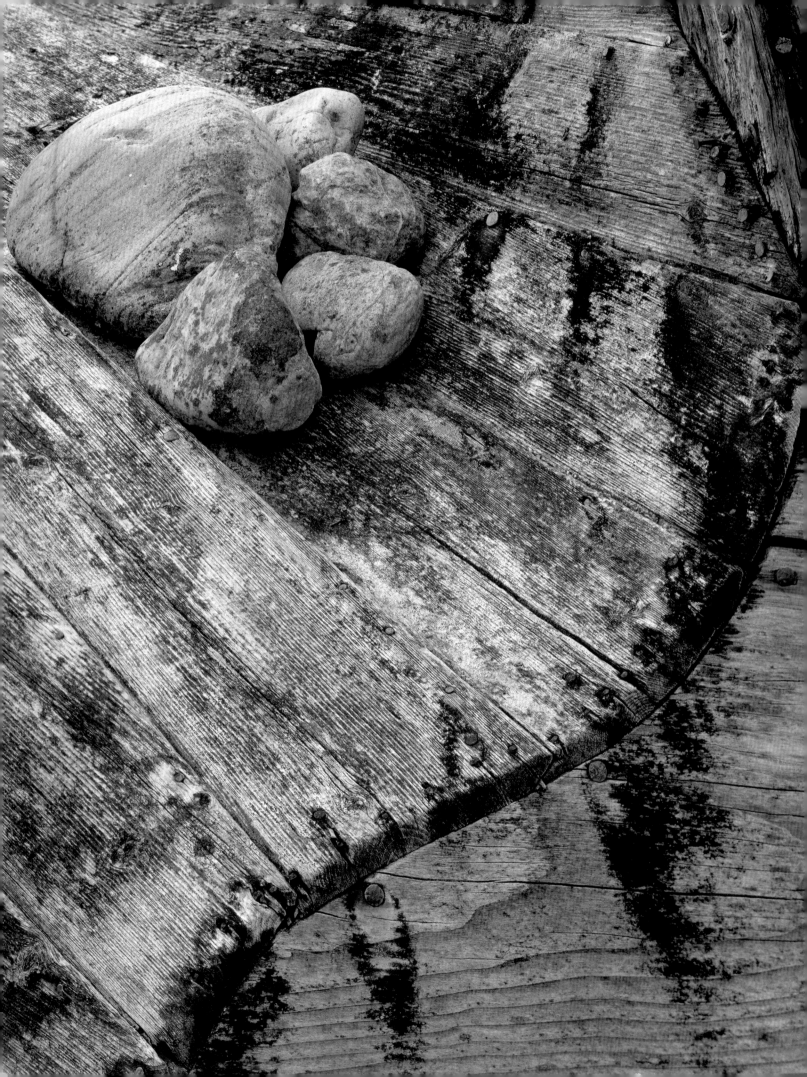

INTRODUCTION

It is not the answer that enlightens but the question.
Eugene Ionesco

The title of this book refers to my continual desire to travel across the photographic landscape, striving for the unobtainable horizon, and to once again look beyond the obvious elements of a photograph: subject, time and light. Photography, for me, is a voyage of exploration. But unlike the famed explorers of the past I don't usually set out with the expectation of reaching a particular destination. Robert Louis Stevenson wrote that, 'To travel hopefully is a better thing than to arrive' and for me the journey is definitely enough. I don't feel the need to achieve a specific target, to tick a box and say that I have taken an image of a particular place. When I set out to make images I do so purely in a spirit of enquiry, I am striving to find the limits of what I understand rather than the limits of the known world.

The essays and images in this book are some of the results of my recent enquiries.

This lack of a goal might seem a bizarre way to approach a genre that could well adopt 'Location, location, location!' as its motto. Landscape photography is largely perceived as being about making images of particular places: Bryce Canyon, Point Lobos, Yosemite, Dunstanburgh or – the granddaddy of them all – The Sea of Steps in Wells Cathedral. These are just a few of the many examples that spring to mind. But I don't wish to reiterate redundantly what somebody else has already said' by repeating views that I have already seen. More than this, my photographs are inspired by what I feel *about* the landscape and are definitely not mere illustrations *of* the place where they are made.

My aim is to make images *with* my subject not *of* my subject. Actually I think subject is a poor word, yet sadly I know of no other that can stand in its stead.

– object is even worse! To me, subject sounds too passive – it feels a little too much like 'victim' for my liking. It makes the photographic process sound impersonal and one-way. But I feel that in my photography I enter into a kind of internal dialogue with the landscape. I am not suggesting that I talk to the trees or that they talk to me and, of course, the landscape is oblivious to my voyages of exploration. But nevertheless an exchange takes place between me and the landscape. It both inspires and arouses questions in me. The places where I make photographs inspire me to form an understanding of them, however imperfect, and through my inquisition answers are sometimes revealed in the landscape.

When I began to plan this book Eddie Ephraums (my commissioning editor) asked me a very simple question, 'What do you consider to be the three essential ingredients of your photography?' I was surprised by my instantaneous response, '*Simplicity, mystery and beauty*'. The certainty and speed with which I uttered these three words made me realise how strongly I felt about these qualities. In each of the first three chapters I discuss one of these essential attributes in a context that extends beyond photography, but I also relate it to the making of photographs. The final chapter discusses the photographer's intent, rather than the image's content, something that it seems to me is often overlooked in landscape photography. All too often the only intent is merely to make a record of a scene.

These essays are inevitably in part conjectural. Art is not science and I am not required to provide a formal proof of my hypotheses. This doesn't mean, however, that I haven't striven to apply rigour in the course of my enquiries. I am first and foremost a practising photographer not an aesthetician – or any other kind of 'ician'. But taking my photography seriously has inevitably led me to seek answers to the deeper questions raised by my art. I have sought answers in many fields of knowledge where I am an enthusiastic and interested observer rather than an expert.

Many of the ideas that I present here aren't new – how can they be when art is almost as old as man? But they perhaps haven't always been applied in this way to photography. It is important to stress that I am not laying down rules or writing a 'how to' manual. My aim is really to provide food for thought and hopefully some fruitful lines of enquiry. I hope you enjoy the voyage into the landscape beyond.

The view from Å
Norway

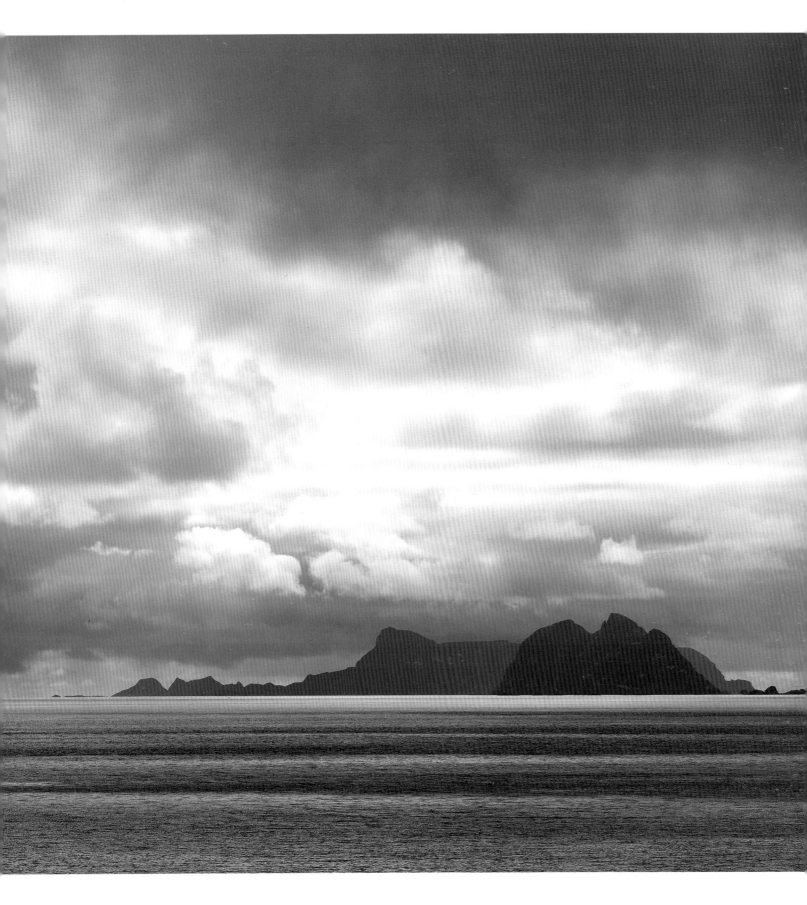

It should be stressed that when I make an image I don't consult a mental list: have I included ambiguity? Is this beautiful? Is it simple enough? Passion and instinct take over and it is only afterwards that I ask why an image worked.

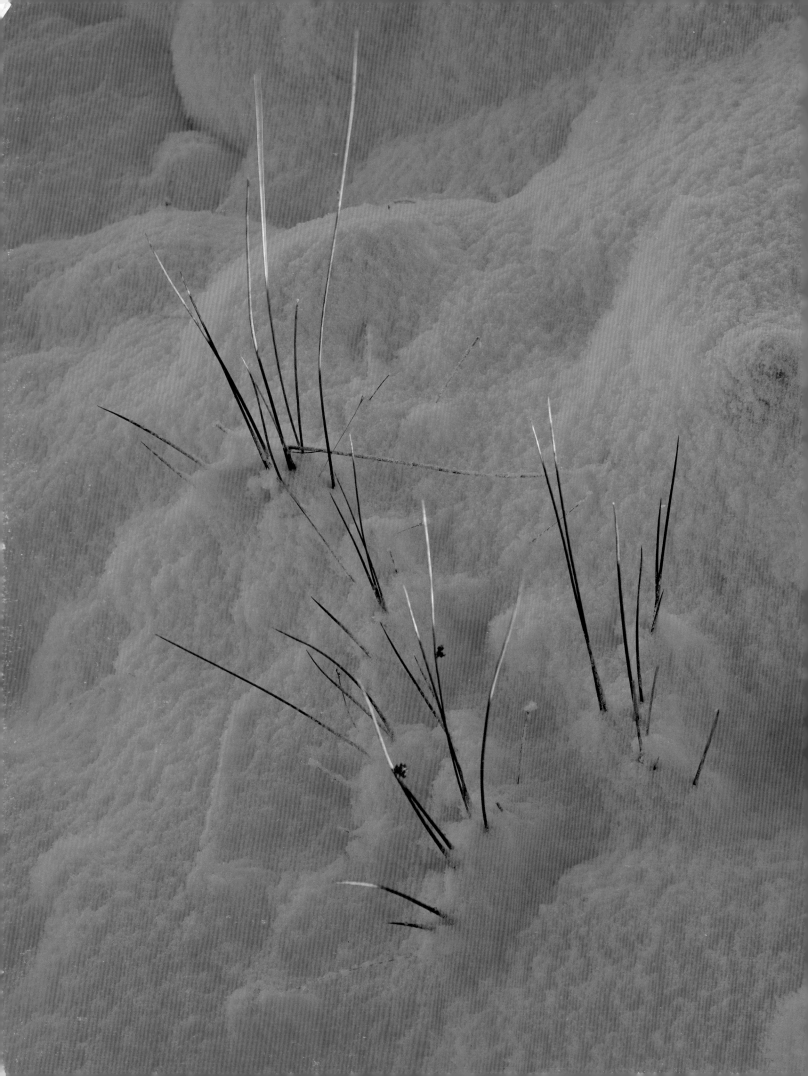

SIMPLICITY

Simplicity is the ultimate form of sophistication.
Leonardo da Vinci

On a recent photography tour that I was leading, the group held an informal image critique session during which a photograph was presented of two stone columns in an abbey in Tuscany. The columns themselves were plain but the capitals were inscribed with Latin text and the whole lit by beautifully diffused window light. The image received almost universal acclaim from the participants except for one lady who was a painter. She couldn't understand our appreciative comments. One might assume that the problem was that the image was too literal, but her main objection was actually that it was too simple; for her, it lacked spatial depth and complexity. I think that rest of the group admired it not only because we found the image beautifully simple but also because we were aware of how difficult it is to achieve simplicity in a photograph. But it is obvious to me that there is much more to admire in simplicity than just how tricky it is to accomplish.

'Less is more…' wrote Robert Browning in his poem "Andrea del Sarto". This famous and pithy line (often misattributed to Mies van der Rohe or Buckminster Fuller) seems to apply to so many aspects of art. For me, it expresses how rich nuances of form can arise from a single brush stroke or how a simple melody can evoke deep emotions. It also conveys how the very best artists in any field can make the complex things that they do appear incredibly simple. Simplicity, clarity and economy of line are things that I strive for in my own work. Experience has taught me that my most graphic images – those with the least in them – are often my most powerful – they say the most. But why should this be?

I want to lead you on an exploration of simplicity (which actually turns out to be

I want to try and explain quite why landscape photographers might value simplicity so much and to explain how striving for it may add something to your images – whilst actually taking things away.

Let's start with a brief look at how the idea of simplicity relates to the process of making a photograph. One of the principal differences between painting and photography is that the former is an additive process whereas the latter is subtractive. Painting moves from a blank canvas – the archetypal ultimate simplicity – toward complexity: whereas photography moves from the ultimate complexity – the world around us – towards simplicity. The painter has the perennial temptation of adding just one more brush stroke. For the painter, the trick is knowing when to stop adding, when to abandon the work. For the photographer, the most important decision is when to stop excluding. Of course painters do this too but it doesn't present them with the same degree of difficulty. I discuss this in more detail below. In photography the image *simply* writes itself in unbelievable detail, the challenge is not how to delineate form but how to extract it from apparent chaos and how to avoid drowning in detail. 'A blank canvas' is taken to mean almost endless possibilities for the painter but the full to bursting 'canvas' of reality offers even more opportunities and complex choices for the photographer. The perennial difficulty for the photographer is the intricate process of separating the wheat from the chaff. These opposing modes of production can have a fundamental effect on the images that are produced, though this is not necessarily so.

In representational painting each application of pigment is added to enhance the whole, to aid the suggestion of form or the fall of light. If the aim is realism then we are talking about an awful lot of brush strokes! Perhaps this is what led 19th Century French painter Eugene Delacroix to declare that, 'A taste for simplicity cannot last for long.' However, I suspect it was more to do with the Romantic Movement's tendency for overblown tableaux on huge canvasses. There is no innate reason for any visual art to be overly complex in presentation. It *can* be simple, and whether any piece of art is indeed simple is likely to be due to choices of style that are conditioned by historical or cultural influences. There have been periods in Western art when an over-abundance of detail has been fashionable, sometimes this was fundamental to the piece, sometimes it was mere braggadocio on the part of the artist, but I suspect that it was often incorporated in order to please a rich patron. It is no coincidence that size has frequently stood for quality. The bigger it is, the better it is. Surely this is true? Well, it certainly seems that many are convinced by Andreas Gursky's huge images.

Cwm Llwch
Wales

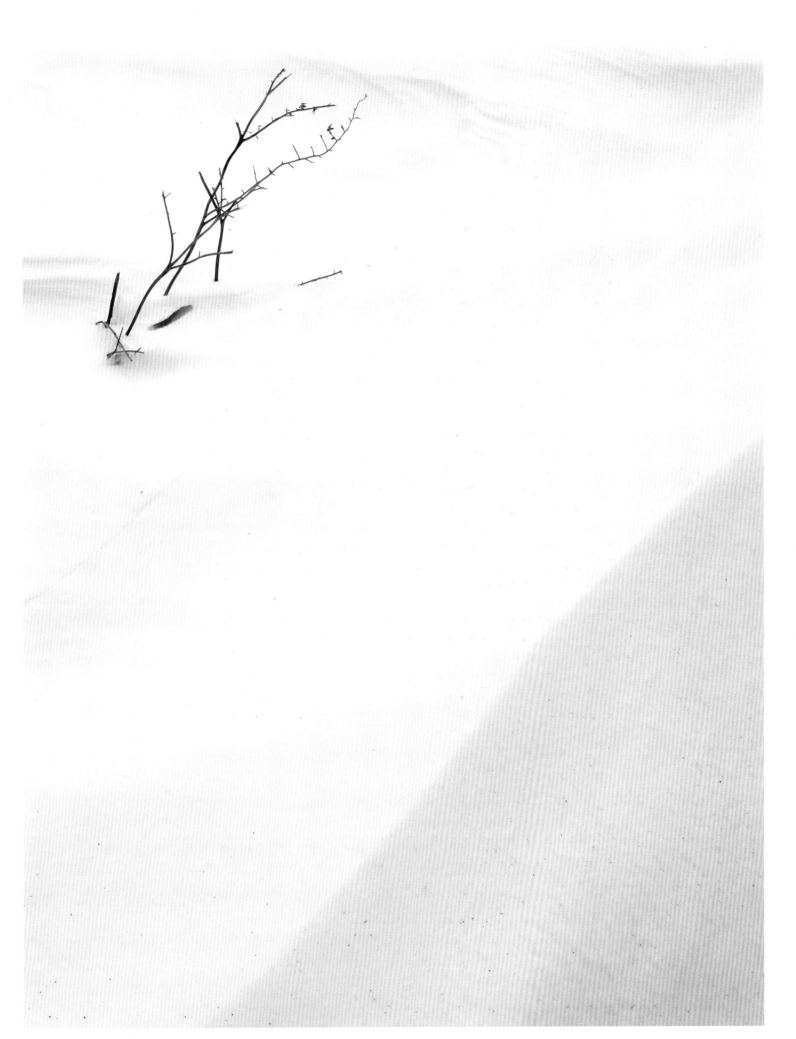

Economy of line – as opposed to the juggernaut of unwanted description – has long been appreciated in the visual arts, noticeably by cartoonists and graphic artists in the West (though also by many other kinds of artists) and more explicitly in a range of Eastern painting traditions. One Chinese aphorism suggests 'yì dào bi˘ bù dào' which roughly translates as, 'Idea present, brush may be spared performance'. The suggestion of form with as few brush strokes as possible, getting the viewer to meet the artist halfway, is a well-known approach that has been used by artists as diverse as Realist painters like Rembrandt or Impressionists such as Édouard Manet. Such techniques rely upon the mind's ability to fill in details where none are present, something that the Impressionists, in particular, exploited fully. This is something that appears simple but is actually very difficult to do.

A photographer's technique is usually invisible in the finished work (and where it isn't we habitually doubt the photographer's ability) whereas technique, the application of paint to canvas or chisel to stone, is all too apparent in other visual arts. Indeed, for the initiated, these maker's marks add another level of meaning, most notably in painting. In-depth studies have been made of painters' brush strokes and how these change throughout their careers. This research not only shows how a painter's technique, style and manner of expression have changed but it is also often crucial in establishing the authenticity of individual works and unmasking forgeries. The difficulties of the painter or sculptor's technique, their mastery of the necessary dexterity, are apparent in the marks that these processes leave behind in the finished work.

But a lack of visible evidence doesn't mean that the photographic process is simple. All good photographs are distillations of a scene in which the photographer assiduously chooses which elements of the scene to include or exclude. This process of simplification is almost as complex as the painting process but, as I noted earlier, transparent. What makes this simplification process so difficult for photographers is that they must always struggle with the elements of a scene available to them rather than being able to adjust fragments, omit portions or even add components to suit their vision as the painter can.

Another difficulty with the simplification process is that quite often only a single 'perfect' combination of light, shade and form provides an ideal solution to the photographer's problem. This is Cartier-Bresson's 'decisive moment', the one and only ideal point at which to release the shutter. In these circumstances a photographer gets just one shot at goal, one chance to achieve perfection at a single attempt,

West from Dyrhóleay
Iceland

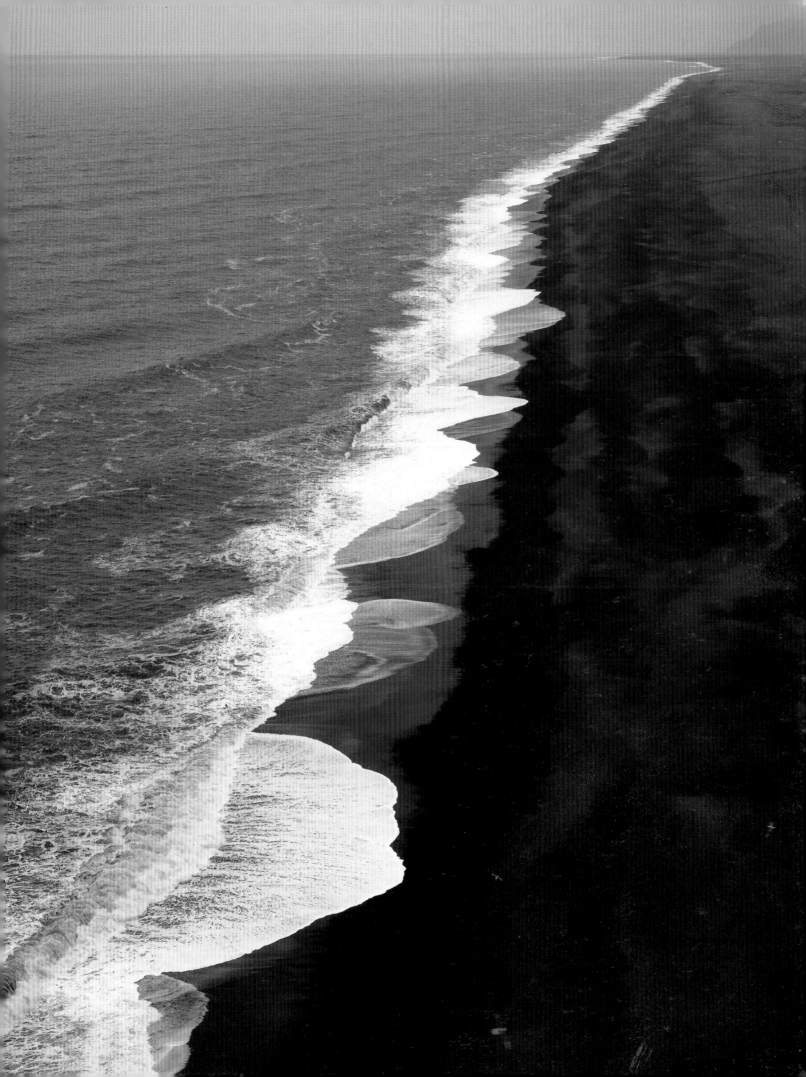

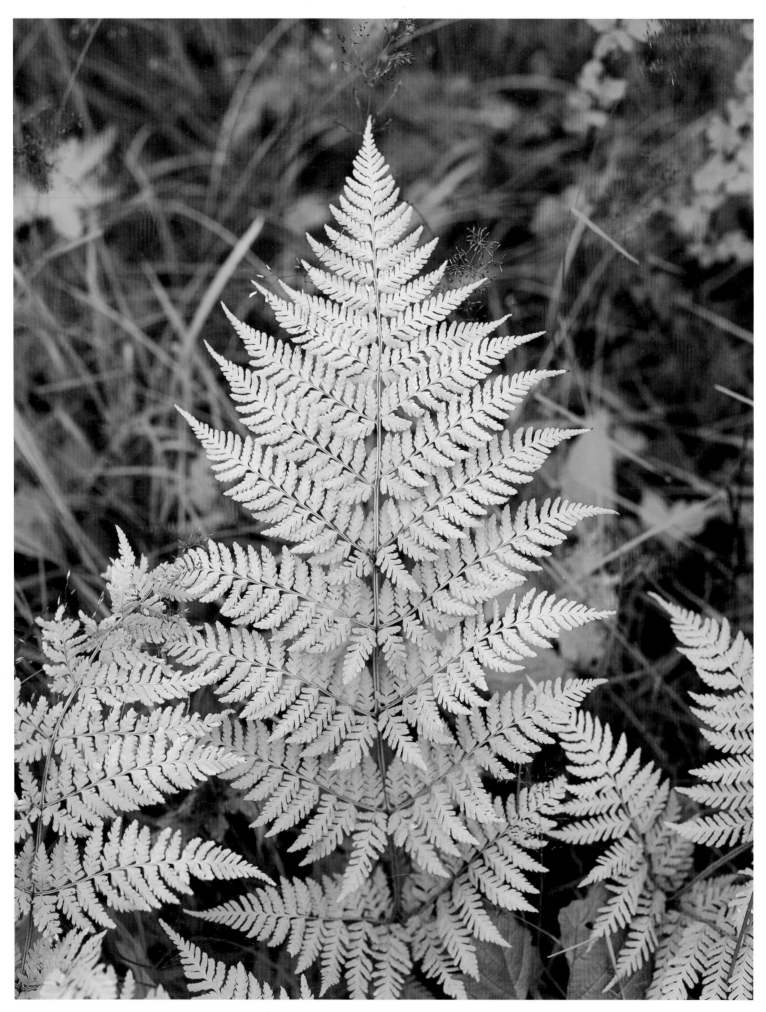

something that is almost unique amongst the visual arts. In this way great photography is more akin to the performance of an outstanding actor or, perhaps more aptly, a tightrope walker crossing Niagara Falls. The photographer must not only be ready to seize the opportunity but also have the requisite skills in order to exploit it to its full potential. Advances in camera technology have certainly made it much easier to conquer some technical issues, such as the problem of exposure. However, composition and framing (in anything more meaningful than a random snapshot) are still problems that only the photographer, and never the camera, can solve. Many photographers, including myself, make matters worse for themselves by insisting on filling the frame with our chosen composition rather than cropping later. There are various reasons why we do this. The desire to achieve the highest technical quality is one of the most fundamental and the satisfaction of getting it right first time in-camera is another. Perhaps more important still is that perspective dictates that a crop from a wider view is not the same as a shot taken closer to the subject.

It is true that, for the landscape photographer, in many situations the decisive 'moment' is considerably longer than an instant. Most photographers can adopt a more leisurely approach and choose, probably unconsciously, to use a camera in much the same way as a painter might use a sketchbook. Painters often experiment in a tangible fashion along the way toward a finished work of art. They may make preparatory sketches, and even when the painting is under way they iteratively apply pigment to the canvas as part of the process for building light and shade but also to overlay previous attempts, obliterating versions that didn't work. Photographers try out different compositions for fit by making trial exposures. Composition is an open-ended puzzle in three or four dimensions. There are numerous 'correct' solutions for any given situation. The advent of digital means that photographers can now assess these test images on location as part of the process of working towards a resolution. This is a repetitive process akin to the layering of paint I discussed above. It is an exploration of possible solutions and, as with a painting, the failed attempts are invisible in the finished work. This invisibility endows the finished image with a false quality of effortlessness. It appears to have been simpler to make than it was.

There is one group of photographers for whom such tangible approaches are impractical. For various technical reasons large-format photographers usually solve the complex multi-dimensional puzzle of composition inside their heads – pre-visualising as Ansel Adams would have it. They must mentally sort through a vast number of possible solutions in order to arrive at the single one that is executed and even, for the relatively laid-back genre of landscape, there is usually some time

pressure imposed by changing light. Of course, there is no guarantee that the final exposure will be the optimal solution to the open-ended problem of composition. If it is, then a masterpiece may be born – but more likely the image will be satisfactory rather than great. However, in order to arrive at a simple solution to these complex problems one needs to either be very practised or very lucky.

It should be apparent by now that although the process of making a photograph seems simple, certainly in comparison to other visual arts, this apparent simplicity is an illusion. Photographers have seemingly bypassed the very apparent problems of mastering complex techniques (no long period of apprenticeship just learning how to mix paint for us) but we still have to solve the equally complex, but unapparent, process of simplifying reality. This simplification is crucial if we want to achieve meaningful results – more on this below.

Time to move on to thinking about simplicity in relation to its obverse, complexity. We must remember that these two concepts are poles at either end of a continuum, rather than a simple dichotomy. For each meaning associated with these poles there is a shading of meaning in between Let's look first at some pejorative connotations for simplicity and the accompanying positive connotations for complexity.

Simplicity	Complexity
Unsophisticated	Sophisticated
Superficial	Serious
Shallow	Deep
Half-truth	Truth

To be simple has an obvious negative meaning: it suggests someone who is ignorant, lacking in common sense or intelligence, a simpleton. This reflects the widespread prejudice that simple things are unsophisticated and that intelligence is associated with complexity. But while it is undoubtedly correct that many deep truths are quite complex the obverse – that something simple must be shallow or false – is patently untrue. The history of science has frequently shown that outward complexity conceals inner simplicity. The apparent complexity was actually an indication of a lack of insight.

Just because a solution is simple or relatively unsophisticated doesn't mean that it is wrong: it may actually be the best solution to the problem in hand. A quick glance around the animal kingdom provides many examples. Sharks are in many ways less

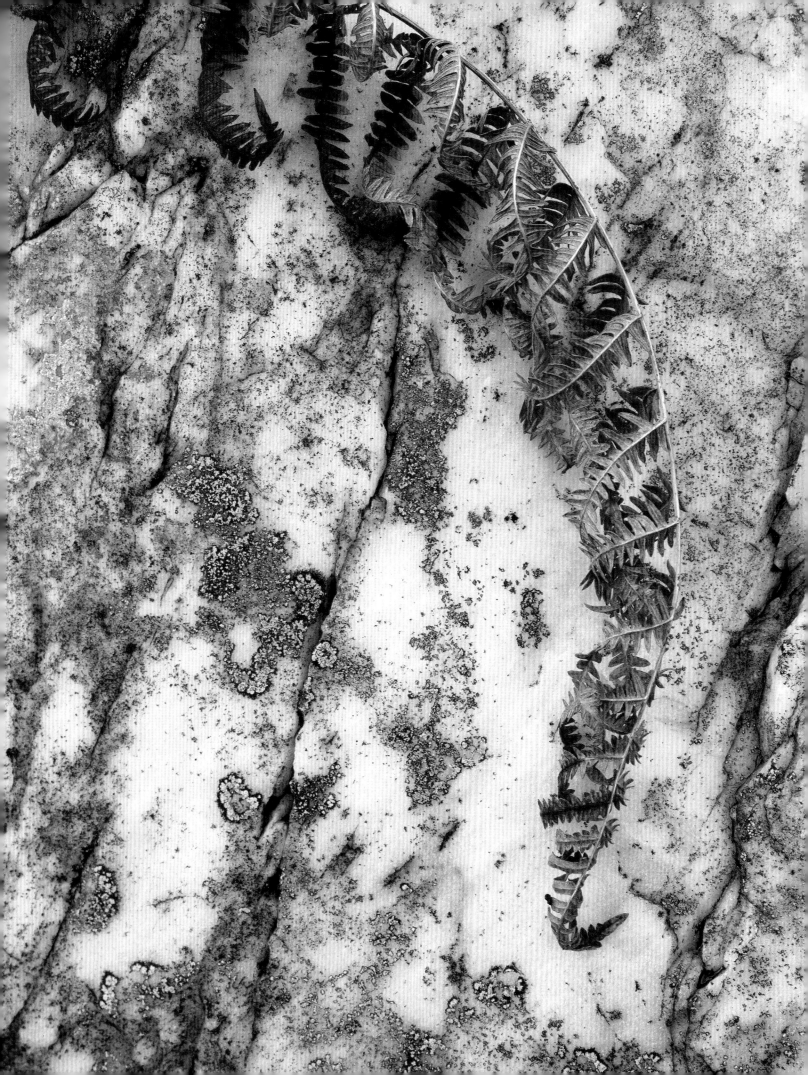

complicated than several of the fish species they share the seas with. This is not surprising since they first evolved around 450 million years ago. Most of the extant shark species have remained largely unchanged for over 60 million years. Not bad for something 'simple', especially given that some evolutionary biologists estimate that around 99% of all the species that ever existed have now become extinct. The secret of their longevity is suggested in the often-misattributed phrase, 'The survival of the fittest' (which was originally coined by the economist Herbert Spencer not Charles Darwin). Sharks have survived for so long in a relatively unchanged state because they are supremely fit for the evolutionary niche they occupy and nothing more 'sophisticated' has fitted the bill quite so well. Their relative 'simplicity' isn't even a consideration. The simple solution is often the best solution to the problem in hand, see the KISS principle later in this chapter for more on this point.

Nevertheless we should be wary of falling into the trap of being simplistic, of presenting shallow observations or half-truths. One sign of being too simplistic in a photograph might be if strong, simple colour isn't balanced in the image by form. Washes of colour can beguile us but if we want to say more than 'Isn't this blue?!' there needs to be an underlying structure. If not, the image will fail to hold our attention for long. In reaching for simple solutions it would pay us to be mindful of Albert Einstein's plea: 'Make everything as simple as possible, but not simpler.' Of course, in science one can check one's theoretical solution against physical evidence but this certainty is not open to artists. Nevertheless, we should constantly exercise dispassionate judgement to make sure that we're not being simplistic or the image will appear contrived.

Such judgements are normally the result of our photographic experience coupled with constructive self-criticism. When starting out it is sometimes hard to judge the quality of one's decisions, experience ameliorates the problem and shows us that good decisions stand the test of time. The images that you still like from a couple of years ago are likely to be those that you will still like next year. They may also be those that have taught you the most but the failures are just as important. The temptation is just to bin an image that didn't work but it pays to study it and think hard about why it failed. Digital technology may make matters worse at this point. Often our intuitive response to a failure is to immediately hit delete, thereby denying ourselves the opportunity for later analysis. If it is a gross technical failure then this may be sensible, but in matters of composition it is better to hold fire and return to the image later for further analysis. There are numerous factors that might make a bearing on your judgement: personal taste, genre norms, wider cultural influences, criticism – constructive or otherwise – by our peers. It might be easier for artists if

Three Cliffs Bay
Wales

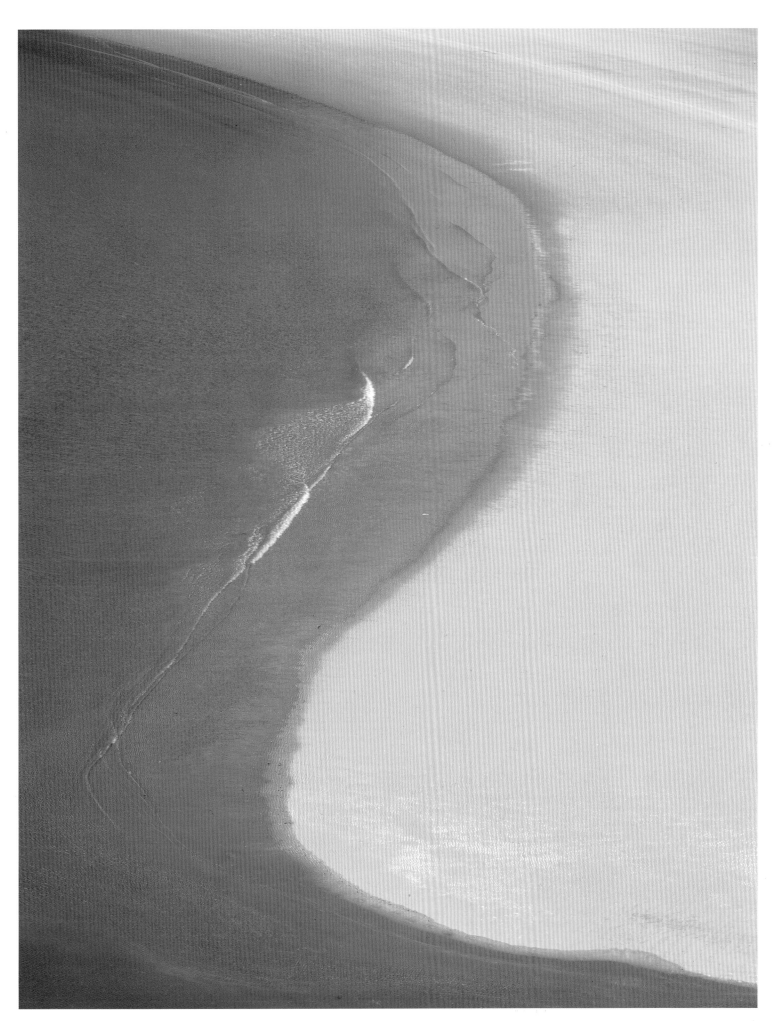

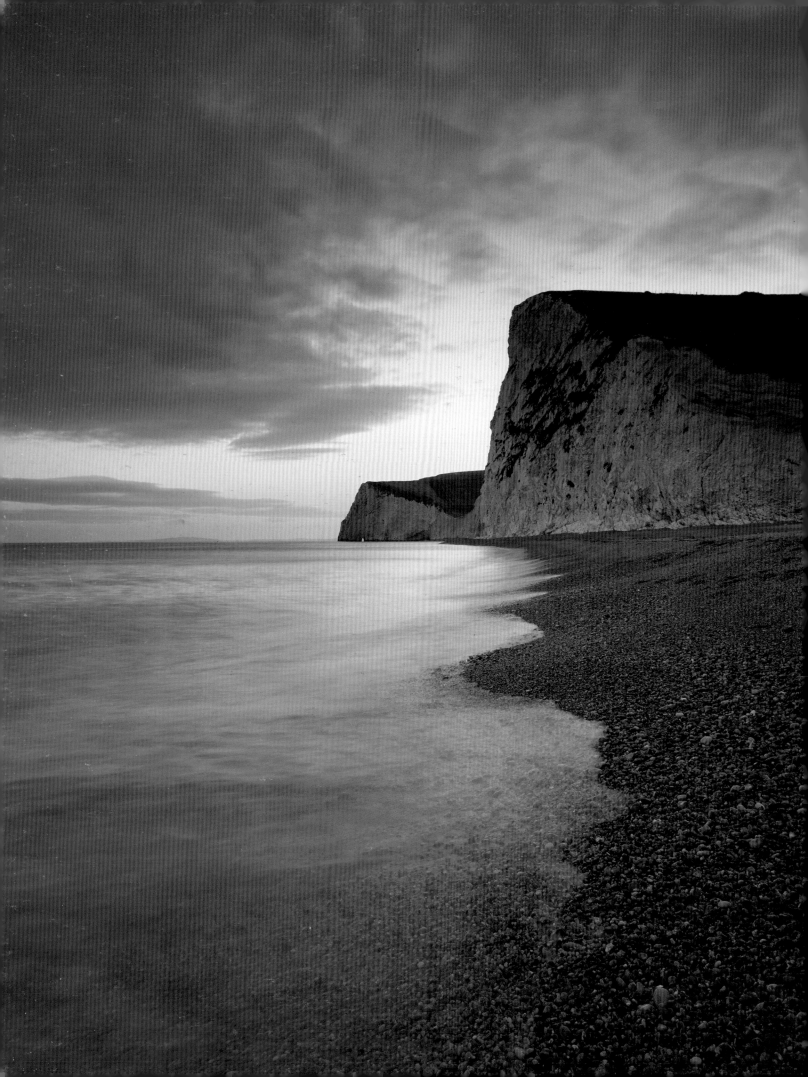

Durness
Scotland

Bat Head
Dorset

there was a healthy climate of popular art criticism from which they could draw direction and inspiration. Sadly, most of the comments in the camera press are too narrowly focused on matters of technique and criticism in the art establishment has largely become too unfocused, self-indulgent, elitist and lacking in rigour to be of much help. We need some structure, or at least a more coherent philosophy, to support the production of art but where this will spring from is anyone's guess. It is perhaps no coincidence that a great deal of art criticism uses unnecessarily complex language. Rather than clearly identifying the core issues, critics seek to hide their lack of perceptiveness behind an impenetrable thicket of verbiage. Sibelius memorably said, 'No one ever erected a statue to a critic.' Which is a shame in a way as they could be a real force for good. Of course it would depend upon the artists taking note.

Let's now look at what I consider positive values for simplicity, and pejorative ones for complexity.

Simplicity	**Complexity**
Easy	Difficult
Unadorned	Embellished
Elegant	Messy
Essential	Unrefined
Clear	Confused

When we seek simplifications of reality to make a photograph our aim is always to make things clearer or easier to understand. The KISS principle (Keep It Simple Stupid) was one of the first things that I was taught as a photographer's assistant in the 1980s. For every problem in lighting or composition there is an obvious but complex way of solving it or a simple, elegant one that is somehow always less apparent. This has been brought home to me on numerous occasions. both as an assistant and as a practicing photographer. When lighting subjects in the studio, for instance, it is tempting to add a spot here or there to add a highlight or lift a shadow but this almost inevitably leads to a confused picture. More often than not returning to a single light and a reflector produces a clearer and more pleasing effect. The key is to always search for a simple solution rather than assume that the answer must be complicated.

As I mentioned earlier, the making of a photograph is necessarily a matter of simplification. I wrote of the photographer making choices, but we must also be

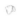

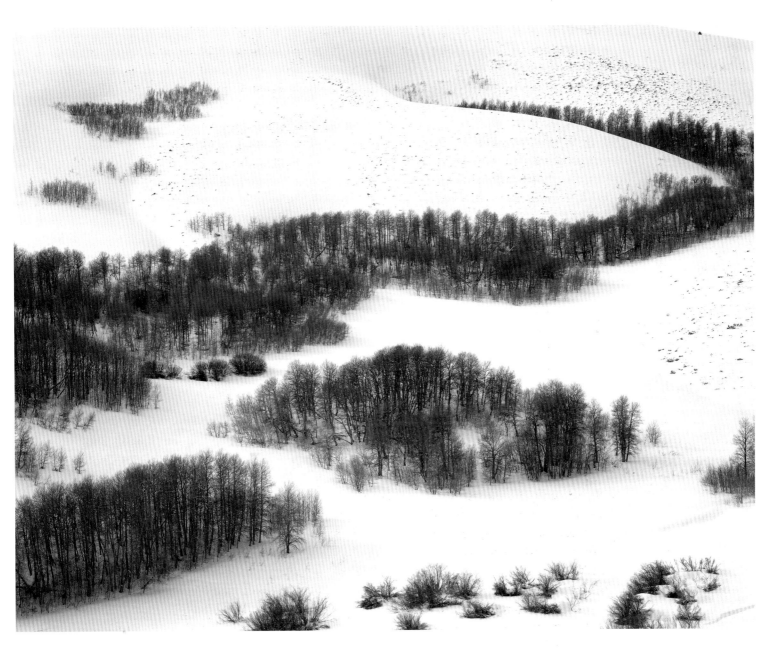

Aspens, Conway Summit
California

aware that some simplification is inherent; the photograph is *of* reality but *not* reality because it collapses four dimensions into two. We can do nothing about this but we may be able to exploit one of the side-effects. The compaction of time is not apparent when the subject remains static over the length of the exposure but when it moves we can use this effect to aid simplification. An extremely long exposure of a moving object reduces the detail in that object; for example, the foam of crashing waves becomes translucent. In the process the photograph moves beyond mere description. If the shutter is open long enough – normally more than a minute – the moving object no longer denotes anything 'real' but only connotes, it becomes purely evocative. Such exposures can even make the visible invisible. This can be used to great effect in urban environments when you can make a building or street scene appear completely deserted, something that I have seen used by David Gepp to make fascinating images of Venice on a large-format pinhole camera.

Beyond such inherent simplification, photographers always need to further simplify what is in front of the camera in order to achieve clarity. There are three main aspects of simplification. Firstly, to remove unwanted clutter from the frame. This is a fairly straightforward process; running your eye around the edge of the frame, for instance, to make sure that nothing unwanted breaks the frame and leads the viewer's eye away from the subject.

Secondly, we simplify to make the space more clearly understood, basically to avoid the situation of not being able to see the wood for the trees. One tip when carefully selecting your viewpoint is that it helps to close one eye in order to get a better idea of how the scene will appear in a two-dimensional image.

Thirdly, and most importantly, we simplify to help concentrate the viewer's attention on the subject. The Abstract Expressionist painter Hans Hofmann wrote, 'The ability to simplify means to eliminate the unnecessary so that the necessary may speak.' I have often seen the potential strength of an image diluted because the photographer lacked the courage to get in closer to his or her subject. This means stripping away all extraneous detail, removing any elements that represent unnecessary embellishments or adornments from the frame. Embellishments might also take the form of obvious or inappropriate filtration. Don't always reach for the polariser or the warm-up filter and never for the starburst. It is frequently better to let the subject speak for itself without any of the 'improvements' that a filter might offer. We are trying to present our subject honestly and obvious filtration announces the photographer and detracts from the image. Strong filtration denotes stylisation

Fish pails
Norway

Abandoned farmstead, Hatch
Utah

Ruined farmhouse, Cosona
Italy

rather than style. It is a mistake to think that it has the same expressive connotations as a painter's brushstrokes. When photographers announce themselves in this way they proclaim their lack of subtlety. Luo Yongxian, a Ming Dynasty Confucian, noted almost five centuries ago that, 'Only when there are no clever tricks at all is true talent seen.'

Photographer Ruth Bernhard wrote that, 'My quest, through the magic of light and shadow, is to isolate, to simplify and to give emphasis to form with the greatest clarity. To indicate the ideal proportion, to reveal sculptural mass and the dominating spirit is my goal.' The problem is it is easy to complicate but difficult to simplify. And we seem to want it all when presented with a vista. We frequently try to include too many disparate elements in the frame: a shapely tree on the left, the curve of the stream, the distant mountain, the large boulder on the right and the sheep in the middle distance. All may work well within a composition but *only* if they can be placed in close harmony with each other within the confines of the frame. The energy of an image is dissipated if the elements sit too far apart with dead areas in between. It is frequently better to choose just two or three elements and concentrate your effort upon finding a simple relationship between them.

But why do we attempt to cram all the wide open spaces into a single frame? A love of the great outdoors is fairly obviously what brings people to landscape photography. We find it a stimulating experience to stand in front of a vista. The problem is that we confuse this experience, and the resulting image in our mind's eye, with how it will appear in a photograph. A straight shot of such a scene is likely to be very disappointing. When we are presented with the image in two dimensions, stripped of other sensory inputs, we come to realise how much of what we thought we saw was actually an illusion. All the areas of the scene that our mind had failed to notice at the time, or had edited out as unimportant, are now rendered in the same exquisite detail as those elements that fired our imagination. They have gained an unwanted and undeserved parity. We always need to make choices and what we choose to exclude from the frame is every bit as important as what we choose to include.

To summarise; simplification is the key. Include only those elements that are crucial to the composition, in order to strengthen the image.

'Composition', Ansel Adams famously said, 'is knowing where to stand.' More than this, it has been my experience that once you have distilled the scene to its essence

Lucignano d'Asso
Italy

the composition will reveal itself. In simplifying we realise the best way to solve the problem of composition. The landscape is a complex subject but understanding that something is complex doesn't mean that one must necessarily present the subject in a complex manner. Clarity comes with true understanding. I am not expecting every reader to become an expert in geology, meteorology, botany and biology in order to be a better landscape photographer – though knowledge of these subjects might well aid your insight. Your *aims* are what you need to understand. One of the most useful things anyone has ever told me is that you need an *opinion* in order to make good images. Great artists are able to present complex things in a simple fashion because they have feeling for the essence of what they are trying to explain or portray. They strip away the clutter in order to reveal this essence. Cultivating this knack is vital if we are to grow as photographers.

I hope that I have made a case for simplicity. It will have become apparent that achieving simplicity is actually quite complex; being simple isn't simple. But it is worthwhile pursuing. The American biochemist Mahlon Hoagland drawing on a lifetime's experience in research wrote, 'Simplicity is indeed often the sign of truth and a criterion of beauty.' For me the simple view is frank, sincere, elegant and beautiful. What more do we need?

Vattarnes
Iceland

Fossilized sand dune, Pariah-Vermillion Cliffs Wilderness
Arizona

Rock fins, Pariah-Vermillion Cliffs Wilderness
Arizona

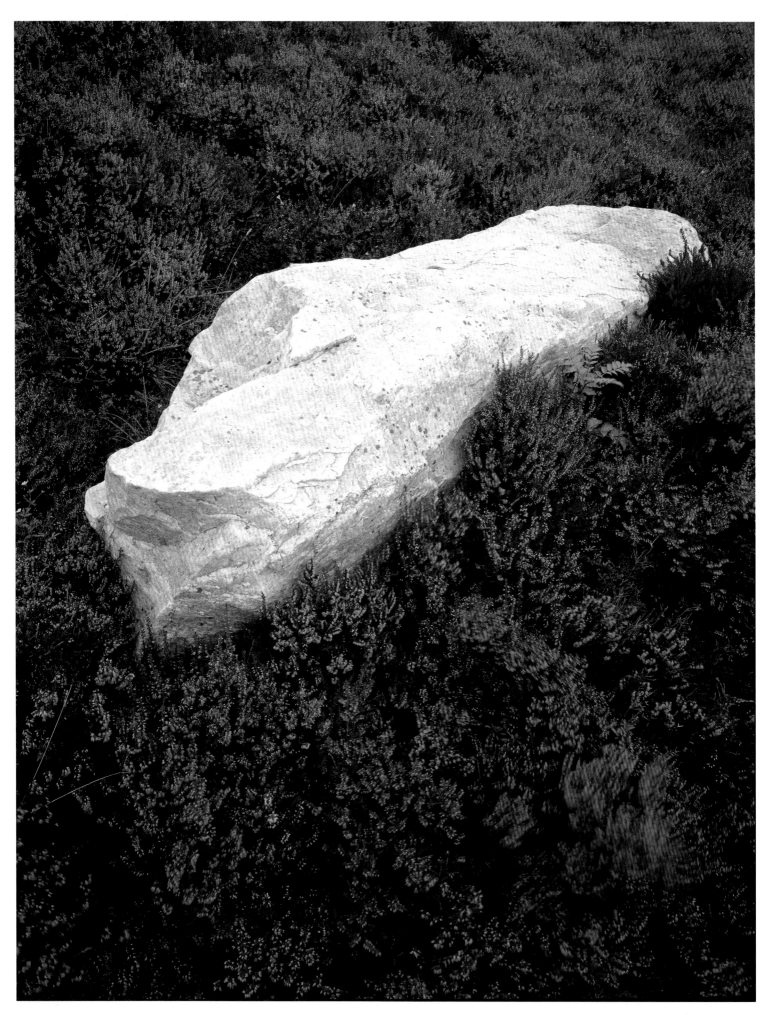

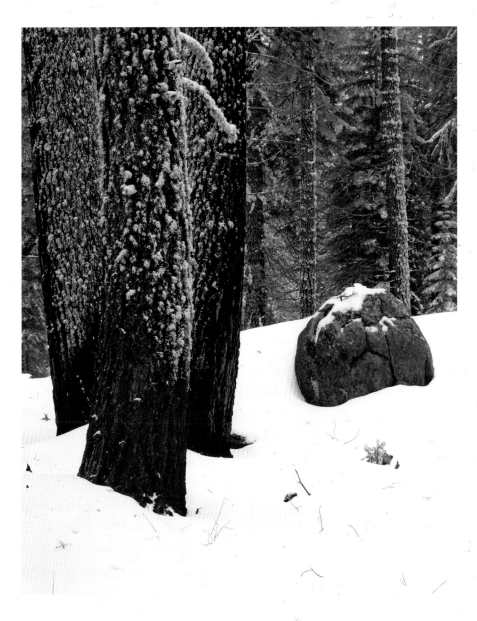

Crane Flat, Yosemite
California

Loch Eriboll
Scotland

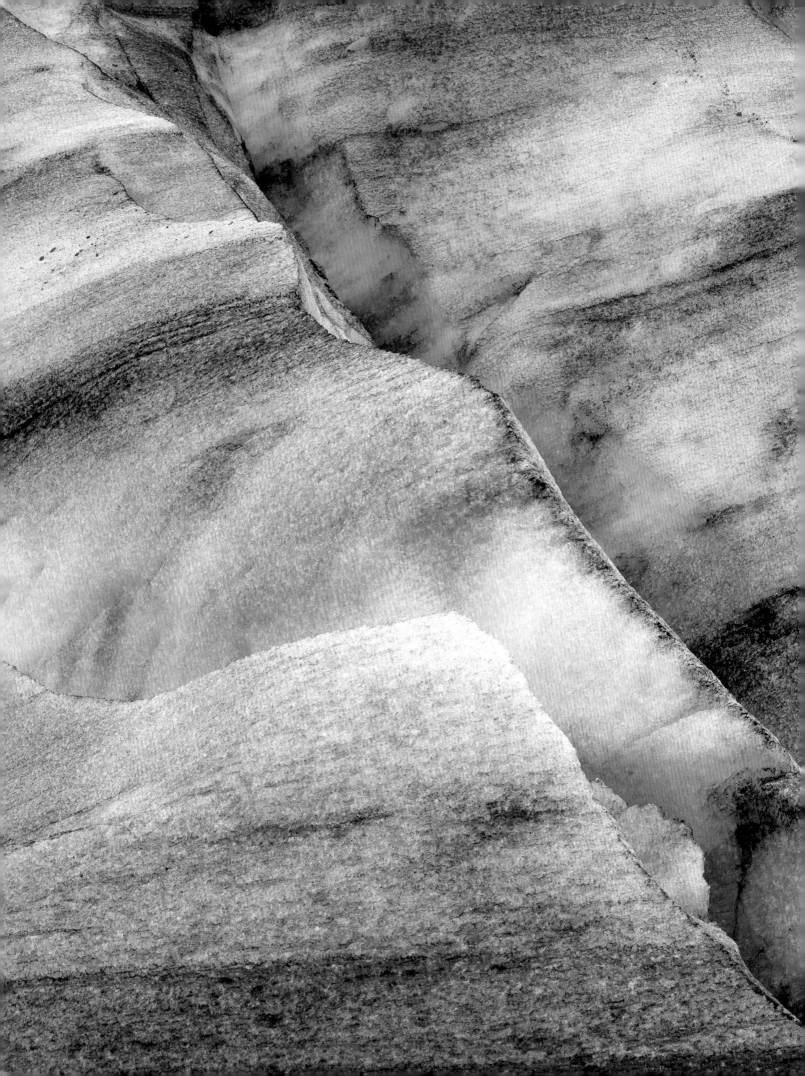

A SENSE OF MYSTERY

The true mystery of the world is the visible, not the invisible.
Oscar Wilde

It is now just over 500 years since Leonardo da Vinci painted *La Giaconda* or, as it is more commonly known, the *Mona Lisa*. Old hat one might think yet, five centuries have failed to dim its appeal. It has become one of the most famous works of art in the world – it has even been celebrated in the popular song performed by Nat King Cole. Around 6 million people every year visit the Louvre in Paris just to catch a glimpse of this iconic painting. *Sfumato* is the Italian word used to describe the way that da Vinci softly blended light and shade in paint, the effect that is credited with giving her smile its unfathomable quality. It has also come to mean that something is ambiguous or hazy.

Though Leonardo's painting technique was instrumental in creating certain aspects of the *Mona Lisa's* mystique, people aren't flocking there to study his brush strokes: they go because in the popular imagination the *Mona Lisa* represents the biggest enigma in art. There is a widespread feeling that Leonardo deliberately constructed this image as a puzzle – that he meant to intrigue us. The *Mona Lisa* has even been described as having the expression of 'the cat that ate the canary', suggesting a smugness at our puzzlement. There are several mysteries wrapped up one inside another in the painting and the sketchy history that surrounds its birth. Who was she? (Although her identity is widely accepted as Lisa Gherardini, this is still in doubt.) What was her relationship to Leonardo? Is she smiling or not? Is she happy or sad or disgusted? Recent computer analysis of her facial expression shows that disgust is one of the possible emotions she's feeling. If so, why? Only one mystery is purely visual: how did Leonardo achieve the mystery of her smile in paint? The others are questions of humanity.

Svinafellsjökul
Iceland

Of course we don't really want explanations of any of the mysteries of the *Mona Lisa*: she would lose her magic and cease to be enigmatic, and the pilgrimages would cease. Visual artists down the ages have understood the need to subtly hook their viewers, to intrigue them. But the approach of most landscape photographers has sadly been a little different.

I recently saw a Special Landscape Issue of a well-known photography magazine – let's call it *Photograph Everything Monthly*. To use its phraseology, the magazine was 'jam-packed' with 'fantastic' landscape photographs from 'experts'. A cursory glance revealed that this didn't appear to be too outlandish a claim, though one might think that I should already have heard of some of these 'experts'. However, having spent a few minutes looking at the images it occurred to me that I couldn't actually remember the image before last, or the one before that. In fact, I could not call to mind any details except from the image in front of me. You might think that it was merely poor visual recall on my part, but I can assure you that this isn't normally a problem I suffer from. I flicked back through the magazine to try to understand why the images were failing to stick in my mind. In general the compositions were strong), the colours were saturated (perhaps too rich in some cases) and they were all reasonably in focus. So what was missing? What failed to make them memorable? It finally dawned on me (no pun intended, but a large proportion of the images were made in the 'golden hour') that the problem was that they were all too clear.

This largely colour work, though of a lower standard, lies within a 'straight' landscape tradition. This stretches back to the 1930s, starting with monochrome photographers such as Edward Weston and Ansel Adams who were founding members of the 'Group f64'. The declared aims of this loose association were to promote 'straight' photography, to move away from soft-focus Pictorialism and to celebrate what they saw as photography's fundamental qualities – its clarity and ability to render fine detail and delicate tonality – rather than to apologise for them. Above all they wanted to promote unmanipulated photography (though dodging and burning and other darkroom manipulations were allowed) in order to emphasise photography's veracity.

Adams was well known as a perfectionist and especially when it came to photographic technique. As the developer of the Zone System he was the first photographer to systematically study and explain exposure and its relationship to the production of fine prints. Working with 10"X8" monochrome film and making quite big enlargements he had the capability of reproducing a huge tonal range

The Wave
Arizona

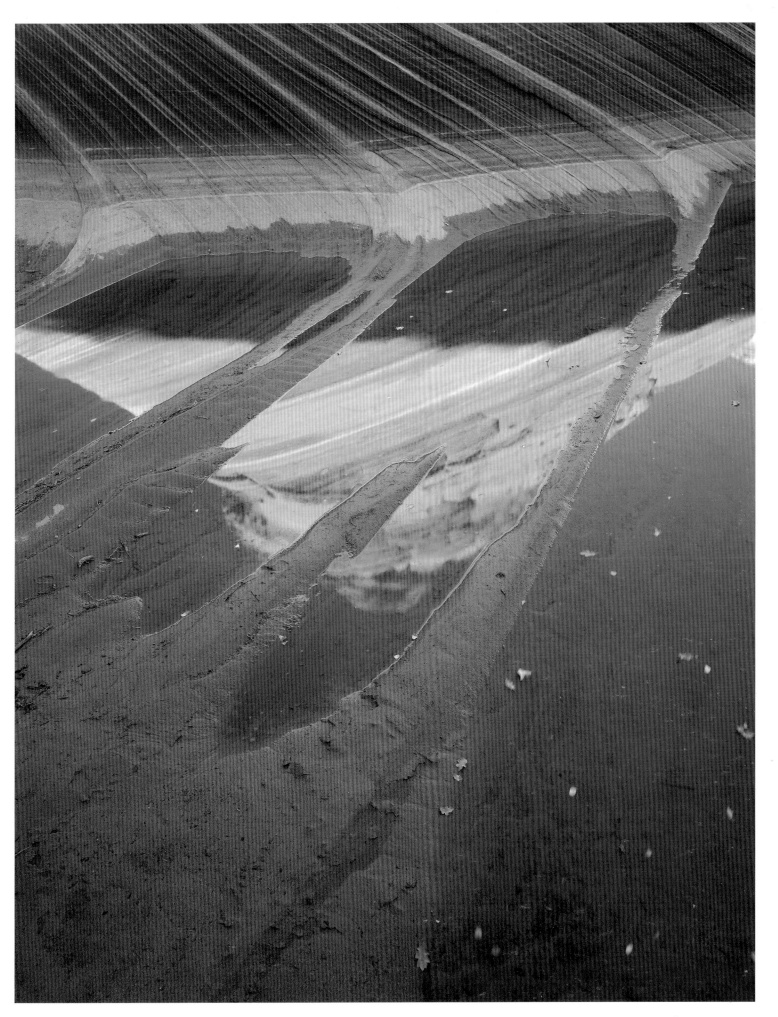

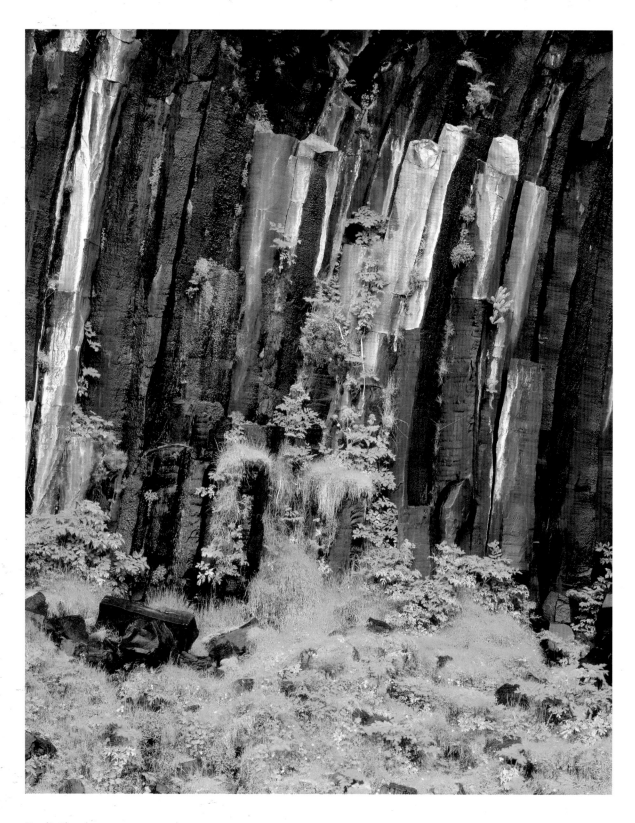

Basalt columns
Iceland

Strangles
Cornwall

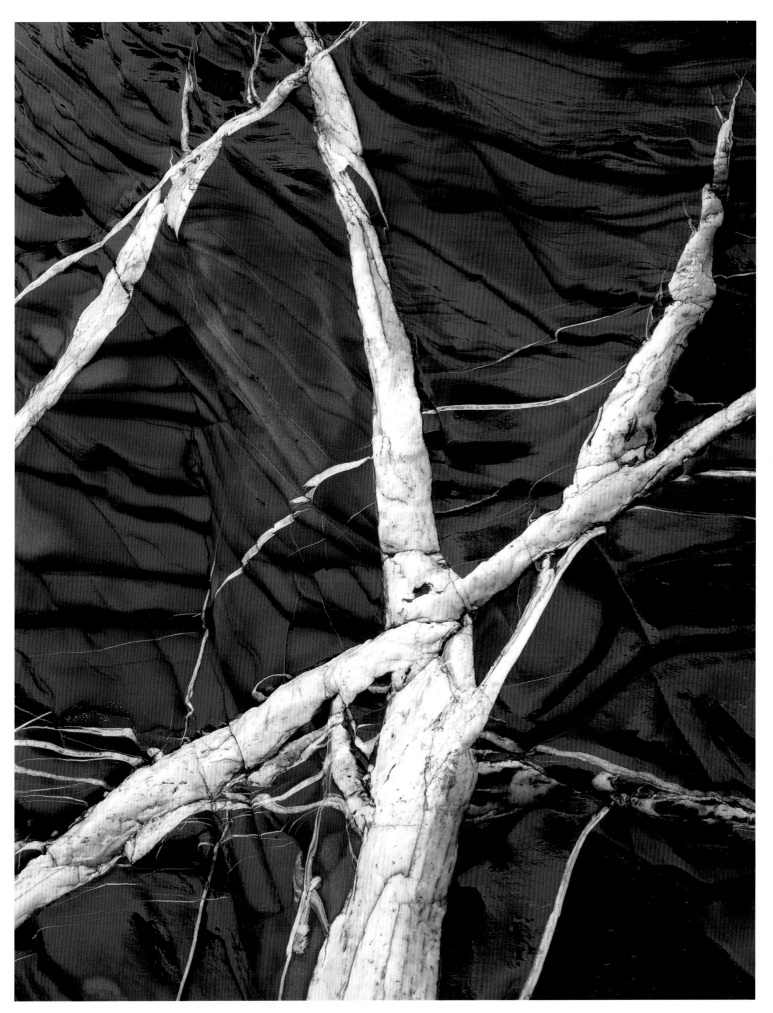

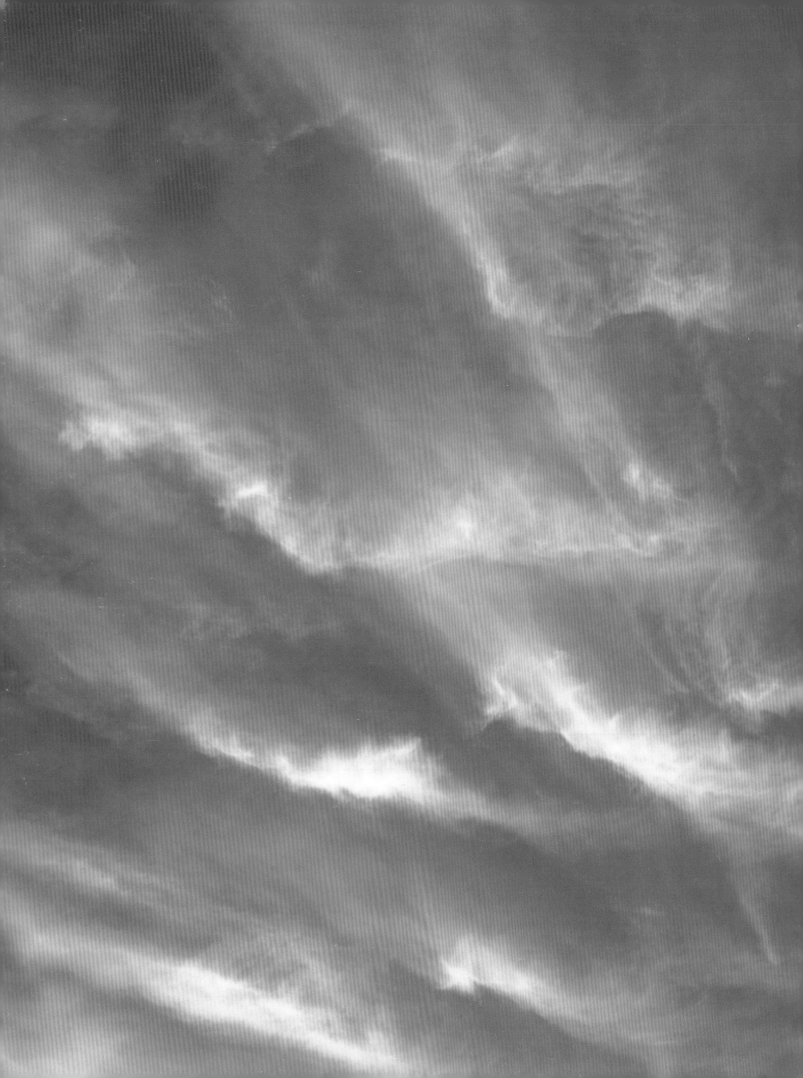

resulting from a latitude of as many as ten stops – hence the ten gradations of the Zone System. Adams' standpoint seemed to be that if you have this potential then it would be a crime not to use it and, at least in the early years, he became obsessed with rendering all the available tones in a scene. One can speculate that his training as a concert pianist played some part in the development of his perfectionism, but it is just as likely that it was a product of his striving for a kind of hyper-reality, a superhuman clarity of vision.

When I went to see the 'Ansel Adams at 100' exhibition in 2002 one of the things that struck me was how lacking in contrast, how 'flat', many of his early prints looked. Every tone was exquisitely rendered but somehow this made the scene emotionally – as well as tonally – flat. I felt a little like Emperor Joseph II (obviously not a *lot* like him!) who famously said, 'Too many notes, my dear Mozart' – too many tones my dear Ansel! There's no doubting their beauty but I wonder whether these early prints are celebrating Nature or photography's ability to render Nature? I also wonder whether, in striving for tonal perfection, Adams didn't become too clinical. When we describe a space too well in a photograph – open up the shadow detail for instance – we may unwittingly remove the chance for mystery.

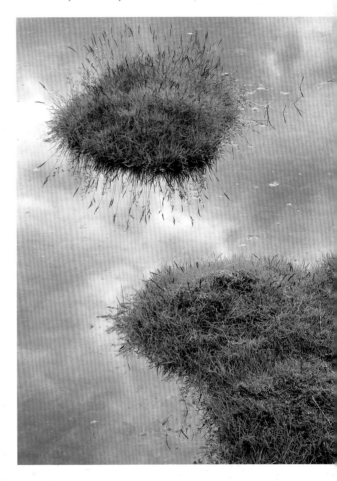

I am not for one moment suggesting that Adams didn't sometimes produce wonderful, mysterious images, just pointing out that too much emphasis on the recording power of photography can produce dispassionate results. Interestingly, Adams seemed to have a change of heart in his later years and reprinted many of his famous images in what has been described as a more 'operatic' style, with higher contrast and deeper, richer blacks. He sacrificed the ultimate tonality in favour of emotion.

What photography does supremely well is explain the space photographed. When the man in the street says a photograph is 'good' what he is saying is how well it explains the space that it is describing, how easy it is to read. What we chiefly want photographs for is

Near Holmur
Iceland

Tuscan sky
Italy

to illustrate spaces and to fix memories. A 'bad' photograph presents a confusing description of a space where it is difficult to understand what we're seeing or hard to recognise Aunty Mabel. This good/bad judgement is based purely upon the descriptive power of photography. But mere description, simple illustration, doesn't excite: it is like reading a very long list that contains no adjectives – tree, hill, cloud, blue sky, blade of grass, blade of grass, blade of grass, another tree, blade of grass etc. There has to be something else to hold our attention. John Loengard, a long-serving staff photographer for *Life* magazine, wrote in 'Pictures Under Discussion':

> A Ming vase can be well-designed and well-made and is beautiful for that reason alone. I don't think this can be true for photography. Unless there is something a little incomplete and a little strange, it will simply look like a copy of something pretty. We won't take an interest in it.

For a long time it was felt that the single strongest impediment to a photograph being seen as art was its overwhelming power to document reality. When a photograph presents a 'perfect' copy it is just a diminished representation of the original; it may tell us about the interests of the photographer but it will not tell us anything new about reality or ourselves. We need something else.

Is this magic ingredient beyond the reach of photography? It has long been a habit of art critics to praise images arising solely from the imagination more highly than those arising directly from reality, as photographs do. But why? Partly it is to emphasise the artist's unfettered vision, but partly photography itself is to blame. Before the advent of photography, many painters applied a huge amount of effort to producing the most realistic rendition of the world possible on a canvass – to portraying the world in as 'truthful' a way as possible. Making the image look 'real' leant it weight as a document. Along came photography, a mechanical process that effortlessly produced images drawn from the stuff of reality. The painters' years of effort suddenly seemed for nought, for how could they compete? A new direction was needed and what was left but to travel further into the realms of the imagination? The imaginary is something that painting can portray better than photography *simply* because its subject doesn't need to physically exist. The largely unchallenged corollary seems to be that if painting (as truculent and insecure senior partner in the visual arts) can portray the imagination better then it *must* be a realm more worthy of study than reality. Kyriakos Kalorkoti, a mathematician who also happens to be addicted to landscape photography and a producer of very fine images, refutes this claim in an article on his website:

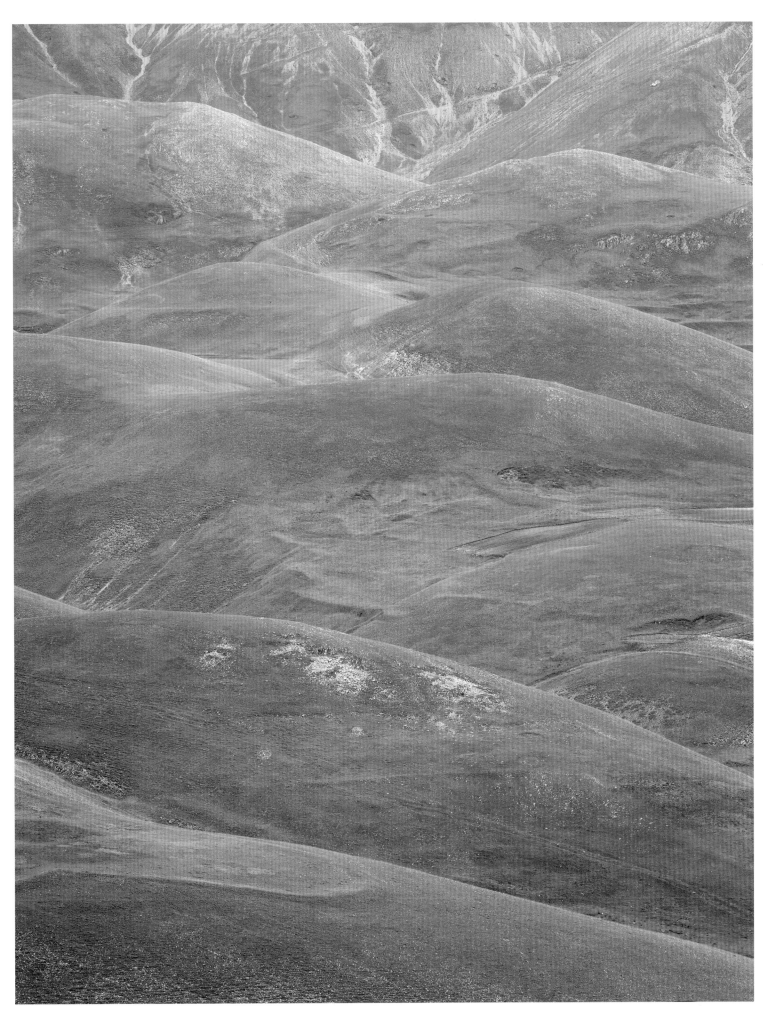

This objection can only be entertained if we go with the facile view that material existence is somehow mundane and thus is of no particular interest to art. In fact existence of any kind is deeply problematic and mysterious; the nature of material reality is by no means straightforward and is thus more than a fitting source for image-making that aims at transformation and revelation.

Despite this reassurance we need to recognise that photography's illustrative power can be a problem. In my own work I try to minimise its illustrative power, principally by trying to break the photograph's bond to the particular. One way to do this, for instance, is to remove the object that is photographed from its context, to extract or abstract it. But no matter how much one tries to minimise a photograph's illustrative power it is, in its most fundamental sense, never diminished. Paul Strand, Ansel Adams, Edward Weston and countless other photographers understood this and sought to make photography's visual clarity a virtue.

To recap: on the one hand photography's strong bond with reality suggests that it is an innately inferior tool for artistic expression. On the other hand photographers have often chosen to champion its illustrative power as its 'essence' at the cost of subtlety and expression. It seems obvious to me that there is a third way.

All photographs are *documents* written by light. They are unquestionable proof of an individual point in space and time. They are true and yet they are not the whole truth. The light reflected from a subject delineates the subject with exquisite faithfulness yet fails to tell us everything. In that failure lies the possibility for expression. Rather than fighting against the 'essential' nature of photography – perhaps by making out of focus images, or using outlandish filtration – in order to achieve expression, a more satisfying approach would surely be to subtly subvert the way the photograph represents reality, by introducing mystery. In this way one might remain true to photography's lucidity whilst increasing its scope for expression.

When a photograph is truly great it is often either because it *fails* to fully explain some aspect of the space it depicts or because it presents us with a visual paradox, a deceptive space. It is incredible not merely for what it describes but also for what it falls short of describing, for what it only hints at. Images as diverse as the *Mona Lisa* and M.C. Escher's *Ascending and Descending* (in which hooded figures process along a never–ending staircase) are outstanding images precisely because they fail to explain themselves. They are visually mysterious, they contain elements that intrigue

Overleaf:
Suilven
Scotland

Budle Bay
Northumberland

Aguereberry Point, Death Valley
California

and hold the viewers' attention. A sense of mystery, ambiguity or deception – these are all attributes that make an image alluring.

I will describe some different kinds of visual mystery below but first I want to relate the discussion above to a particular aspect of how human vision works. Vision evolved as an aid to survival; it helps us to find food, it helps us to avoid being food and it helps us to navigate the environment in which we live. In all these situations it is useful for us to be able to make very quick decisions based upon the visual information we're receiving. This information is just part of the sensory input we have to assess before taking any action. The visual puzzles that we're continually presented with need to be solved quickly in order to be able to avoid harm and move on to solve the next in a continuous stream.

Imagine yourself running through a jungle. The ground underfoot is rough. For every step you need to coordinate the physical feedback from your limbs with your vision in order not to stumble. And you need to do this quickly! There are plants crowding in on every side. How low is that branch? Will your head fit under it? Do you need to duck? All the while the leopard that you glimpsed indistinctly for a fraction of a second through the trees is gaining on you… It soon becomes apparent why evolution has taught us that it is best to reach for what psychologists describe as early closure when processing visual input.

So, when we're shown a photograph our instinct is always to try and understand the space presented to us as quickly as possible and then move on to the next image. If the depiction is unambiguous we may move on with hardly a second glance. That's why the images in the 'Landscape Special' failed to captivate me. In each case the space was instantly understood, there was no visual mystery. Unless it holds some personal significance for us or reveals some truth (see Chapter 3 for more on this subject) we scan an image briefly and then our vision wanders on to the next. It doesn't hold our attention.

Of course looking at photographs is rarely a matter of life and death and we can afford to delay closure if we are persuaded to. The critical element is the persuasion and the two tools we have for this are subject and composition. A photographer's choice of subject is largely a matter of personal choice and is beyond the scope of this or any other treatise on photography, but I want to very briefly look at composition.

Eureka Mine, Death Valley
California

I am often asked by workshop participants to give them the secrets of good composition, 'What are the rules?' they ask. The 'rules' basically establish various approaches to representing the world in an easily understood and forceful manner; they give us strategies for strongly directing the viewers' eye and leading them on a prescribed path through the image. Rules can offer support when we start making images; they act in the same way as stabilisers on a bicycle when we're learning to ride; they stop us doing anything too radical or dangerous when what we need to do is just master staying upright. As we learn so we want to explore the boundaries of our capability and then the stabilisers start getting in the way. Similarly, we are increasingly likely to wish to move beyond the routine application of the rules of composition as we grow in confidence and ability.

Sometimes we don't want our images to be easily understood. Sometimes we want to be mysterious. The photographer's direction of the viewers' gaze must then necessarily be less forceful and more subtle. Simple rules are never going to get us to this point! For me the very best images always break the rules – they surprise the viewer with a new way of seeing the world. Rather than direction of the viewers' gaze being the paramount objective of good composition we should think of balance as the mark of a good composition.

From looking at my own work and that of other photographers and visual artists, I have identified four different kinds of visual mystery that may persuade the viewer to tarry because they are likely to generate questions such as 'Why?' 'How?' or 'What is it?'. These mysteries are: scale, spatial ambiguity, lighting and incongruity. Let's consider each of them in turn.

Scale

When the scale of an image is indeterminate our imagination can be let loose. This type of image is always a portion of a landscape rather than a wider view since scale can easily be determined within a vista. Typically such images are also abstract in nature or, one might say, they are abstractions of natural forms.

The detail photograph is quite different from an abstract landscape. The detail still relates to the whole – we are aware that it is a definite *selection* of a whole, we feel the dislocation of continuity – whereas the abstract landscape photograph represents a self-supporting world. We know that space and time continue outside the frame but don't have any longing for a description of them. The detail can tantalise, the abstract – even whilst being ambiguous – represents a satisfying whole.

Etive wave
Scotland

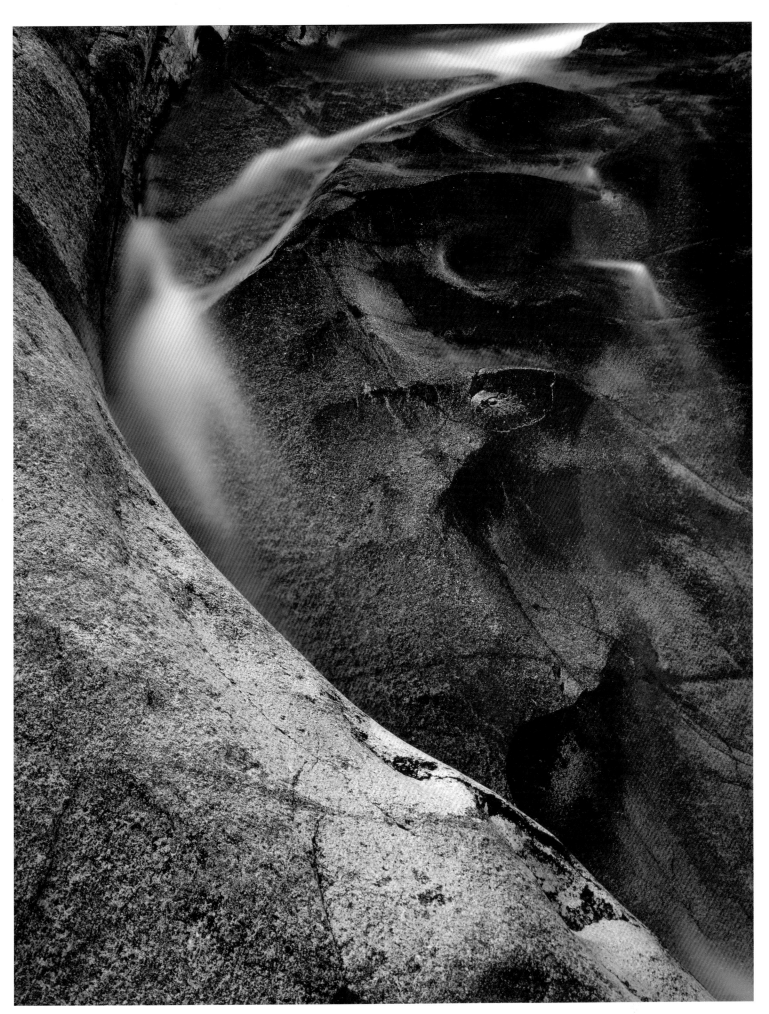

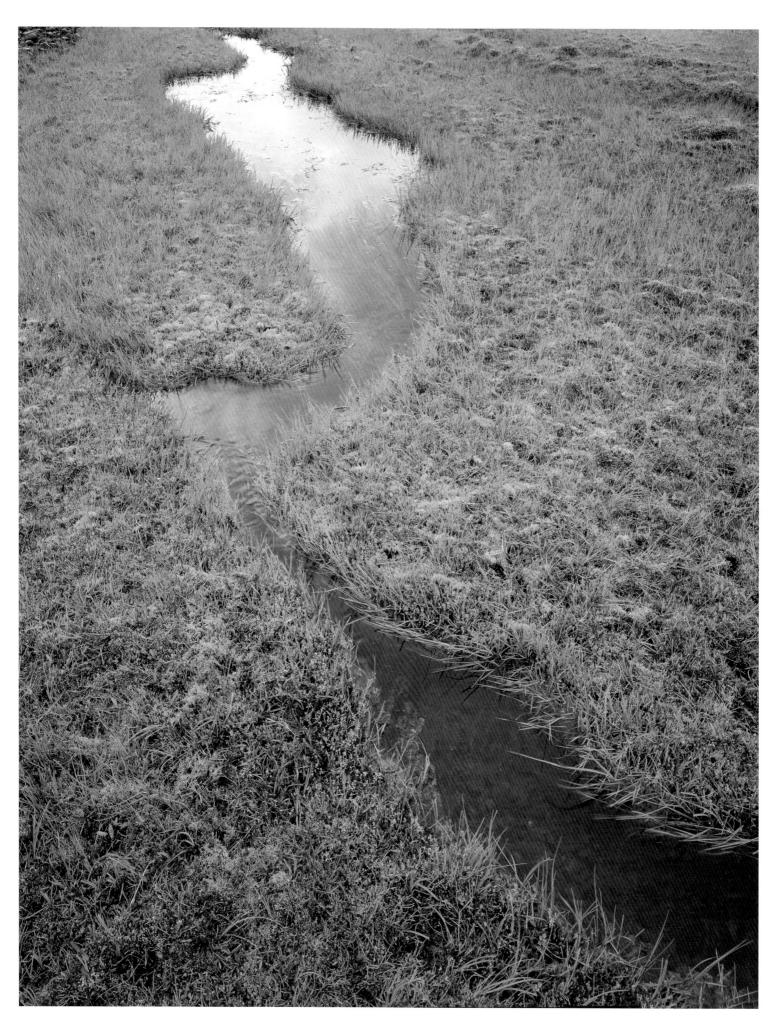

A fascinating aspect of natural forms, and especially geological ones, is that they sometimes exhibit self-similarity at different scales, so a view of a small part of a coastline might be mistaken for an aerial view or even one from space. This dislocation of scale fascinates precisely because the boundaries are uncertain. My answer to the classic comment, 'Why didn't you include something to show the scale?' is 'Why would I?' Doing so destroys the possibility of mystery.

Spatial ambiguity

One might be tempted to lump the mysteries of scale and spatial ambiguity together but they are quite different. Spatially ambiguous images are akin to optical illusions. There may be an uncertain scale but it is the suggestion of something other than what was photographed, perhaps the impression of a face or the outline of a torso, that makes them different.

In perceptual psychology an ambiguous image is one where our interpretation flips from one state to another and we can't hold both images in our mind at once. In the classic example the image is either a young woman in a feather boa or an old crone with a large chin, never both. Ambiguous photographs of the natural world are not so clear-cut. They suggest something other than what has been recorded but still retain the meaning of the original scene. The human mind is adept at finding outlines within complex patterns – a handy skill when you're trying to spot a leopard in the undergrowth. We're particularly good at finding faces. So good in fact that we see them where none exist. The mind has the ability to conjure something out of nothing and it is this facet of vision that often gives rise to spatial ambiguity and a sense of uncertainty that can be used to intrigue the viewer.

I say 'used' as if one might design such an image and then just go and make it. My experience is that this is impossible outside the artificial confines of a studio. All we can hope to be is open to the possibility of finding such a situation. Whenever I have made such images (and it has probably been fewer than half a dozen times in any year) I have rarely fully understood their significance at the time of making. Something has drawn me to the composition but the full impact of its ambiguity has not become clear to me until I have viewed the image on a lightbox. I feel certain that my subconscious mind had recognised the ambiguity and that this had intuitively driven me to make the image. It is likely that the ambiguity becomes apparent to our conscious minds only when four dimensions have been collapsed into two in the photograph. The physical feedback that gives us depth perception is

Near Holmur
Iceland

likely to make such ambiguities hard to perceive in 'real life'. Making an ambiguous out-of-focus image is easy. Making one where everything is recorded in the clearest, sharpest detail yet the image still leaves the viewer with a sense of uncertainty as to what has been depicted is much, much harder. I am not referring to the 'bad' photographs I discussed earlier in this chapter that have failed as illustrations of a space through poor composition, framing or technique. The ambiguous image succeeds on all these levels but also manages to illustrate more than one space within the same frame.

Lighting

Something half-glimpsed in the shadows can often stay in our minds longer than an image fixed in our minds in the cold, clear light of day – developing in the imagination to achieve a significance it may not actually deserve. This is something the directors of horror movies understood perfectly in the days before CGI. Better not to fully reveal the monster but to let it grow in the viewers' mind into something far more terrible than anything they could show.

Even badly composed landscape photographs are unlikely to be described as horrific but we can learn something from this approach. Quite simply we want to know more about the object half-seen. Pitch-black shadows create indifference but a suggestion of detail is intriguing. As an added bonus, dark tones can signify different moods, such as sombreness or melancholy, depending on the context.

Areas of clear film, or pure white in a reproduced image, are usually seen as representing a complete lack of information, and are hence often considered a sign of poor exposure technique. It is possible in black and white photography to achieve mystery in entirely high-key images, though I have yet to see a colour image of this sort that convinces me. But far from being a wasted portion of the image, white can signify purity or simplicity and lend an ethereal quality. Think of a mountain peak partially veiled in cloud: a mysterious image. Think of the same peak in clear conditions: an illustration. The cloud changes the image, moves it beyond illustration by connoting something more than simply 'mountain'.

Incongruity

An image containing incongruity is quite simply one that prompts us to ask questions such as: 'How did that goat get up the tree?', 'Why is the man with the gun smiling?', or 'What are those men doing with a canoe on a glacier?' It is no accident that none of my examples specifically relates to expressive landscape

May Beck
North Yorkshire

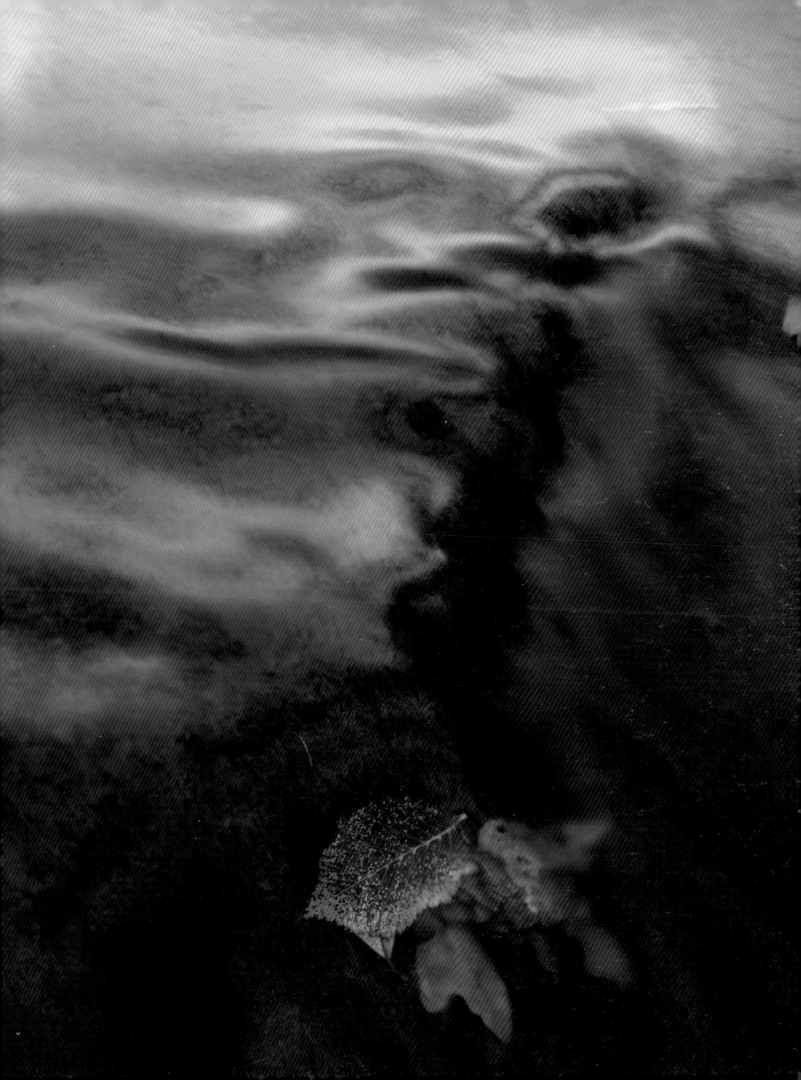

photography. In what we might call 'pure' landscape such incongruities often point at manipulation (either during or after the making of the image) since true incongruities in the landscape are either very rare or their significance is arcane. Erratic boulders are examples of such an incongruity but they have no strong connotative force except, one presumes, amongst geologists. But incongruities are reasonably common in other genres, particularly social documentary or wildlife photography, where facial expression or gesture or any of a thousand other signifiers can seem 'out of place'.

Manipulation of a landscape image merely in order to intrigue is widely thought of as a cheap trick. In this respect photographers generally still like to take their landscapes straight. The digital age has brought with it tools for 'improving' upon reality. Once you have a tool there is always a temptation to use it, and many stock- image libraries now routinely blend skies from one image with the foreground from another in a cynical bid to increase the image's economic value – not so bad, one might think, except that sometimes it appears that we're living in a solar system with a binary star: one is lighting the clouds and the other is lighting the foreground from the opposite direction! However much I am advocating a move away from a straightforward approach, I am not in favour of such radical manipulation. Whether incongruity is readily available for straight landscape images may be a moot point but it is a quality that gives rise to mystery and is therefore worth watching out for.

Time to draw some conclusions. My aim in this chapter was not to replace one set of compositional rules with another. What I want to do is present the idea of mystery as a rich seam of opportunity for the photographer. How you mine it will depend upon your individual approach to photography. It is perhaps also worth stating that I am *not* advocating mystification or deliberate obfuscation in order to suggest some spurious 'deeper' meaning. I have proposed the inclusion of the different mysteries in order to add depth, texture and nuance to photographic images, to

Lochan na h-Achlaise
Scotland

The Wave
Northern Arizona

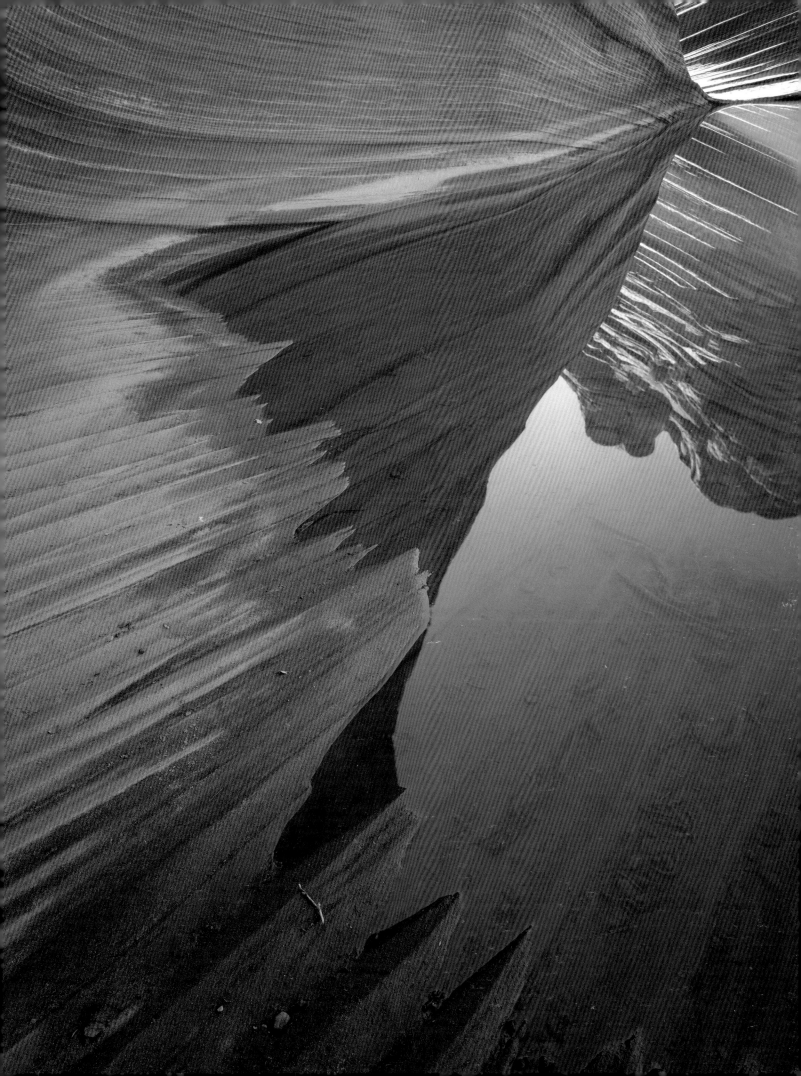

go beyond the mere clinical recording of a scene which the photographic process seems to invite. Often these visual mysteries are present in a finished image but by accident rather than by design. All I want to do is bring them to your attention so that their inclusion might become deliberate.

Throughout this essay I have talked of using mystery as a tool to hook the viewer, as a subtle compositional device, but we shouldn't forget that mysteries can be deep, unanswered and perhaps inexplicable questions. The perception of mysteries and the struggle for revelation of an accompanying truth is one of the principal concerns of artistic endeavour. As Kyriakos pointed out, reality is no less mysterious than the realm of the imagination, so this is an undertaking in which photographers should feel as able to take part as any other visual artist.

Mysteries lie all around us, even in the most familiar things, waiting only to be perceived.
Wynn Bullock

Near Alta
Norway

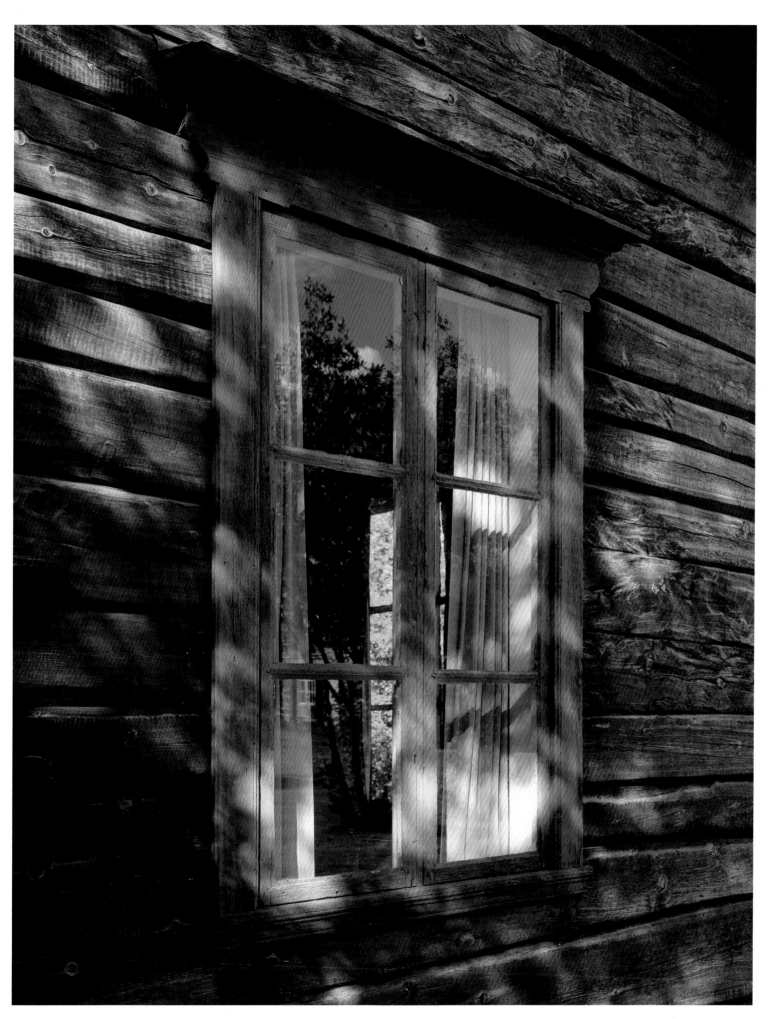

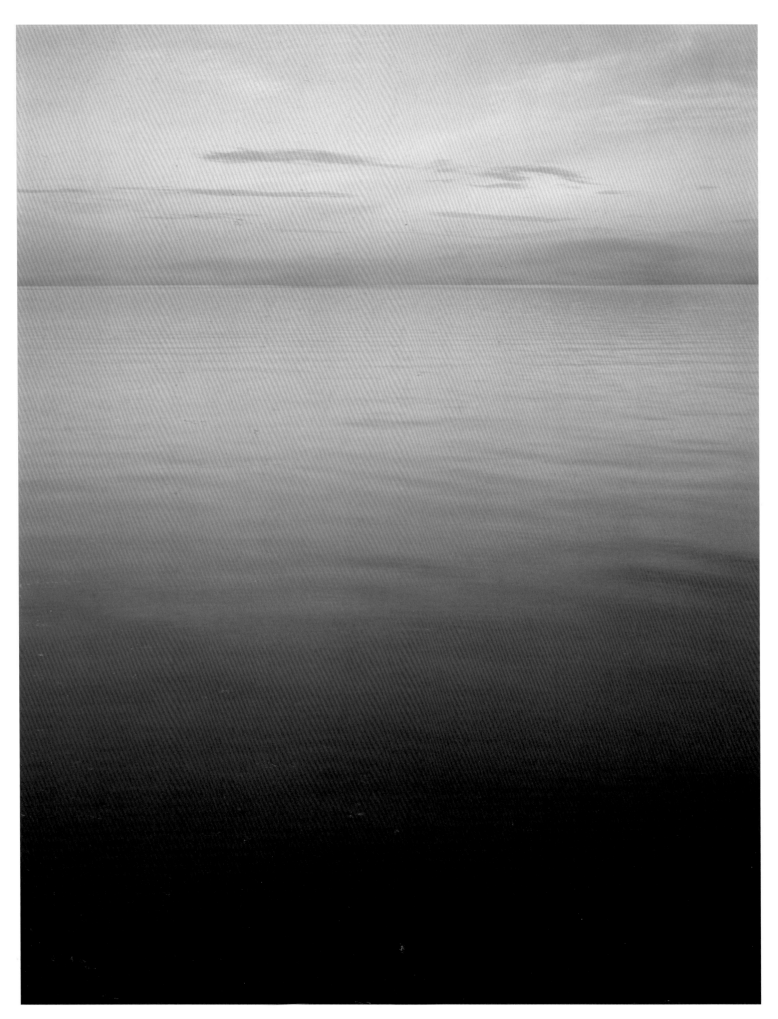

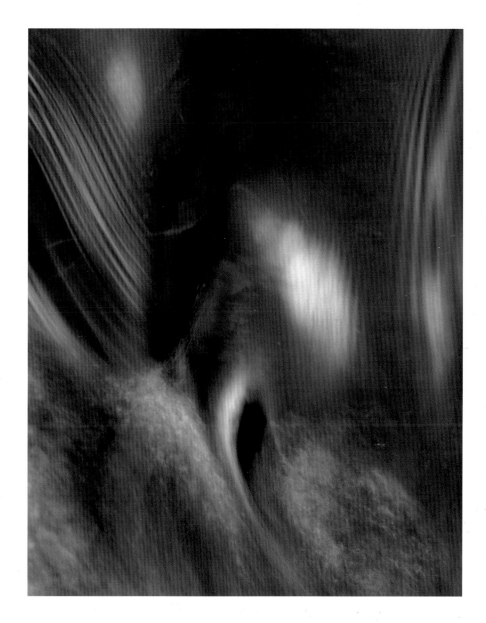

Rannoch Moor
Scotland

The Irish Sea
The Isle of Man

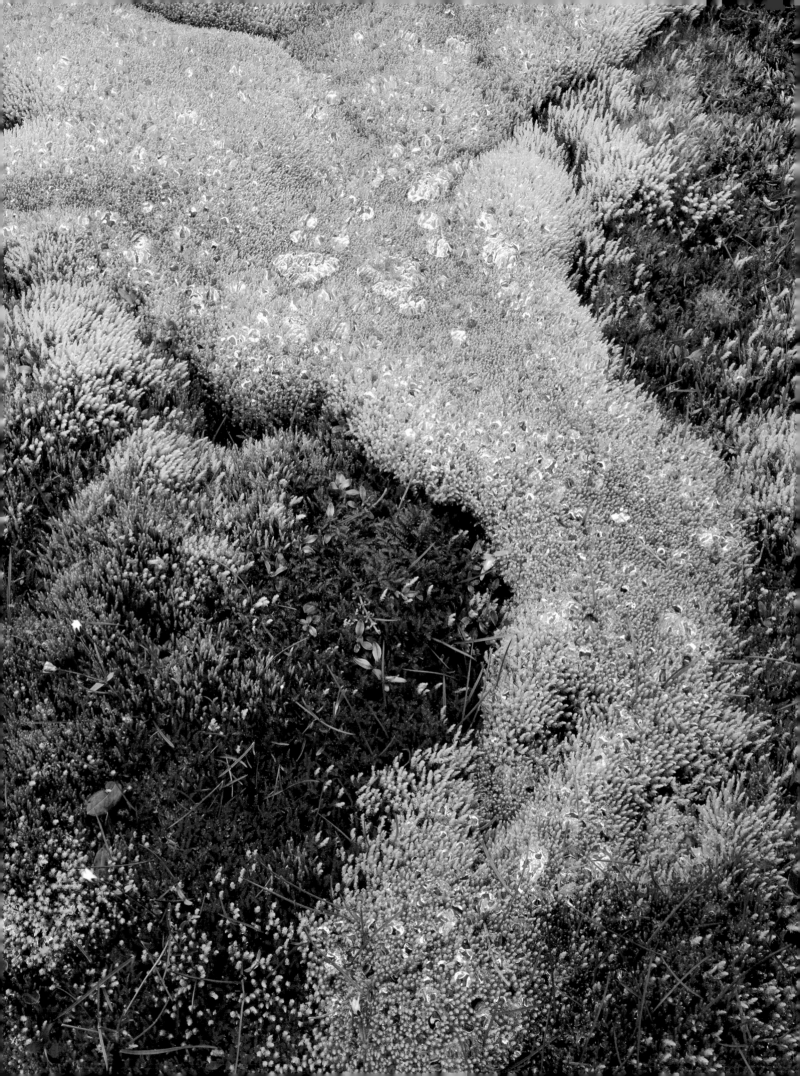

A RETURN TO BEAUTY

Beauty pains and when it pained most, I shot.
Ernst Haas

A debate almost as old as photography is whether we take or make photographs. I've always felt strongly that we make images, that it is a creative act. `Take' has always seemed too passive, too casual, as if the images were lying around waiting to be picked up by any passing photographer. Knowing how hard it is to produce good photographs, `take' has thus seemed to be an almost derogatory term. But I've recently realised that in one sense photography is all about taking, that it has an acquisitive side. It seems to me that when I'm looking for subjects for my photography I'm actually looking to capture their beauty; one might say that I'm seeking to drag an image of that elusive quality back to my lair so that I may feast my eyes upon it at leisure. William Somerset Maugham put it much more eloquently: 'Beauty is an ecstasy; it is as simple as hunger.'

Only a tiny minority of photographers start solely with an attraction to the process of photography. Fascination with a subject, finding beauty in the world around us, is the motivation for image-making/taking for most photographers. The great American photographer Edward Weston wrote that he started to photograph because of 'amazement at subject matter'. I think that this childlike sense of wonder is, whether the subject is wildlife, people or landscape, the one factor that links all expressive photography. My sense of wonder as I walked amongst the hills and mountains of Britain led me to want to record their beauty, and photography seemed to me the most appropriate tool.

From wonder grows a desire to do the subject justice, maybe to reveal to others how you feel about the subject or perhaps just to make those feelings clearer and deeper to yourself. Photographs, when they are successful, can surprise even the author of the image because they reveal some hidden truth, either about the

subject or about the author. Most of us will have had that `Eureka!' moment when we see an image on screen or on a lightbox for the first time and it wildly exceeds our expectations. It doesn't happen very often. Ansel Adams was probably right about his 'twelve epiphanies in one year', twelve times when an image seems to sing, when it appears to be so much more than the sum of its parts. But, there can be a kind of alchemy at work in the mundane chemistry and that magic seems to me to be linked to beauty.

For us as photographers, a search for mysterious beauty is also a search for the wellspring of our passion for image- making. I believe that this quality is both the motivator and an essential part of any truly great photograph. But beauty is a complicated subject – it isn't a single indivisible property but raises diverse questions, from aesthetics to psychology. Thinking about these might help us find it more readily and better understand its significance in our photography.

John Cleese once played a Renaissance Pope who had summoned Michelangelo to explain his rendition of the Last Supper. He was unhappy with the aesthetics of Michelangelo's composition and wanted to know in particular why the painting contained a juggler, a kangaroo and three Christs. Michelangelo's answer that 'the fat one balances the two thin ones' failed to mollify him. Cleese finished the sketch by screaming in his inimitable style at a hapless Michelangelo, 'I may only be the bleeding Pope but I know what I like!' This is a telling and amusing confirmation of Margaret Wolfe Hungerford's famous assertion that 'Beauty is in the eye of the beholder'.

The phrase highlights the most obvious quality of beauty – its particularity, the way that beauty binds one person and one object. There is a strongly weighted feeling in Western cultures that beauty is predominantly a matter of individual taste. In the English-speaking world Hungerford's oft-quoted line seems to have been at least partly responsibly for this skewed viewpoint. It has become so well known that we cannot think of beauty without it popping unbidden into our minds. The concept of beauty that she's describing is a very narrow one. It best explains beauty in relation to sexual attraction and the often unfathomable relationship between one person and the object of their desire. It's another way of saying, 'Love is blind'.

Whilst aesthetic beauty may not be truly universal, beauty is thought of as having universal qualities. At a basic biological level, humans find bilateral symmetry beautiful. Evolutionary psychologists argue that this is because a member of the

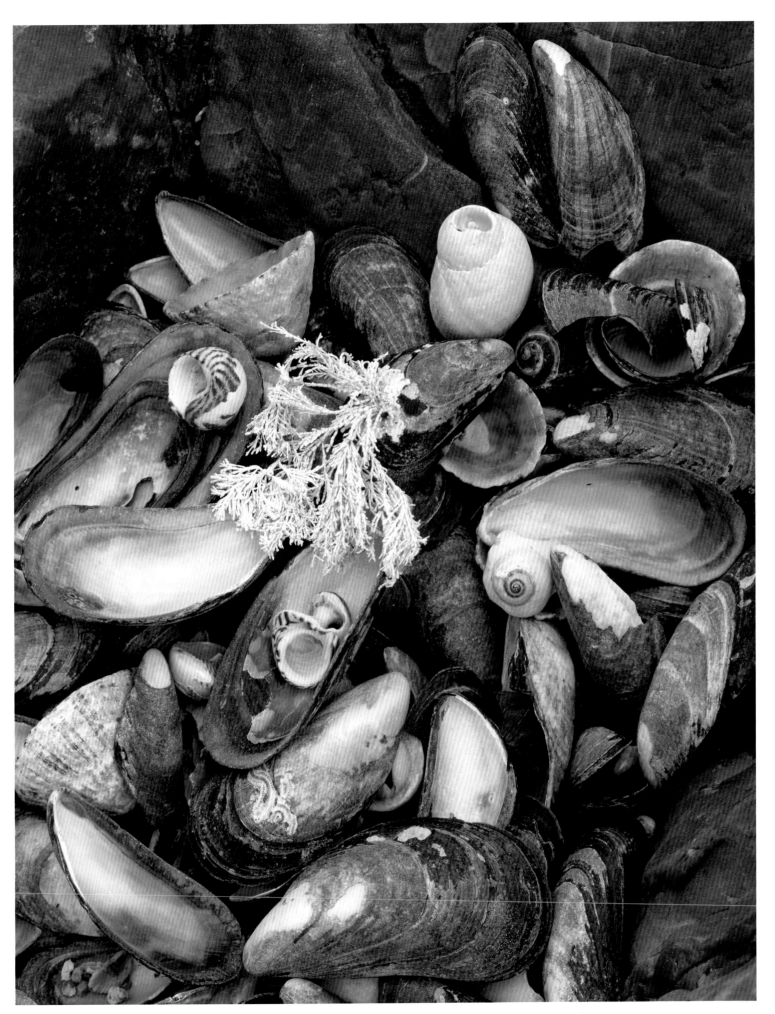

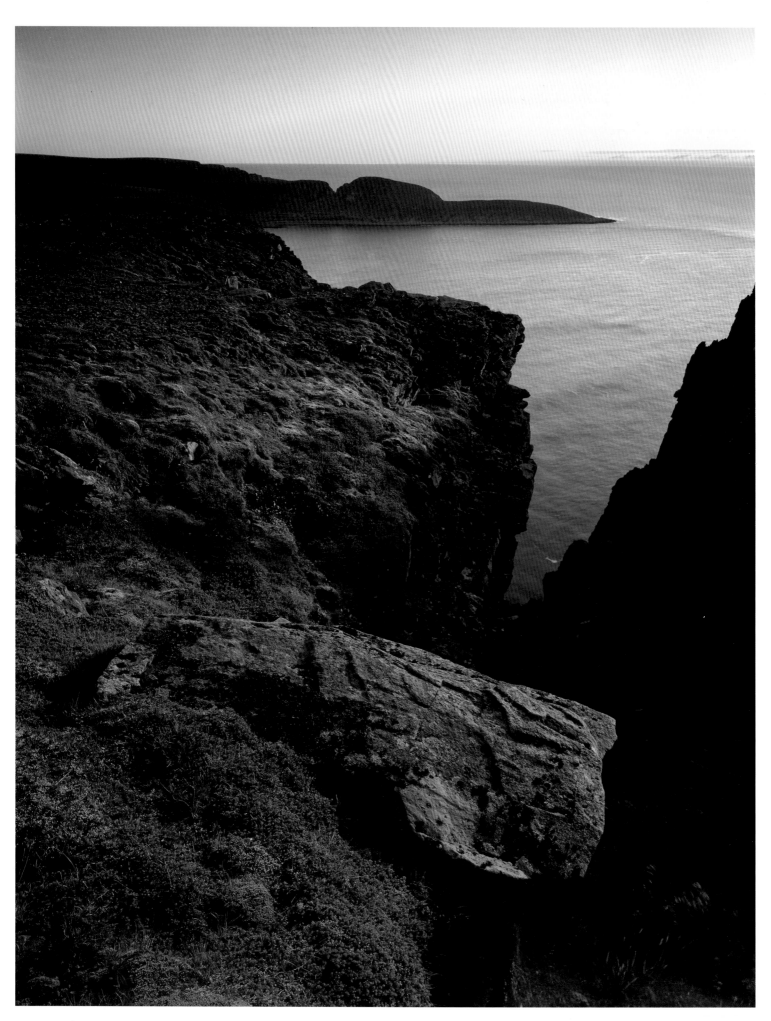

opposite sex who exhibits symmetry is more likely to be, in the evolutionary sense, fit. Certain genetic disorders and injuries or illnesses in later life result in asymmetry and research has shown that individuals exhibiting these traits are less likely to produce viable offspring. We find symmetry beautiful and the search for symmetry/ beauty in potential mates is a facet of natural selection. Another aspect of beauty that is held to be universal is apparent in John Keats' famous line from *Ode on a Grecian Urn*:

> Beauty is truth, truth beauty – that is all
> Ye know on earth and all ye need to know.

The intuitive linking of the notions of beauty and truth has a long history stretching back at least as far as Plato and the Ancient Greeks. The association between beauty and deeper meaning is not solely a Western one but seems to be cross-cultural. The Navajo, for instance, have the word `hozho', which is normally translated into English as 'Beauty' but actually, as one anthropologist explains:

> `Hozho' expresses the intellectual concept of order, the emotional state of happiness, the moral notion of good, the biological condition of health and well-being, and the aesthetic dimensions of balance, harmony, and beauty.

Despite this long-standing philosophical connection there can logically be no proof that something beautiful is inherently truthful or untruthful. Yet many scientists and mathematicians express the view that mathematical proofs or solutions to scientific problems are beautiful. The visionary, writer, architect and designer Buckminster Fuller wrote, 'when I have finished [working on a problem], if the solution is not beautiful, I know it is wrong'.

So, beauty on the one hand is seen as being intensely personal and therefore of little account; yet on the other hand humans intuitively feel that beauty has deep and universal importance. A striking feature of the aspects of beauty that I've touched upon so far is that they seem to arise when something is fit, or rather fittest, for purpose. There is something here that seems to link the particular and universal aspects of beauty and I will return to this later in the chapter.

Given its uncertain nature why might beauty be important to photography? When Alfred Stieglitz, the man many consider to be the father of modern photography, wrote, 'Beauty is the universal seen', he meant that humans all recognise beauty

Knivskjelodden from Nordkapp
Norway

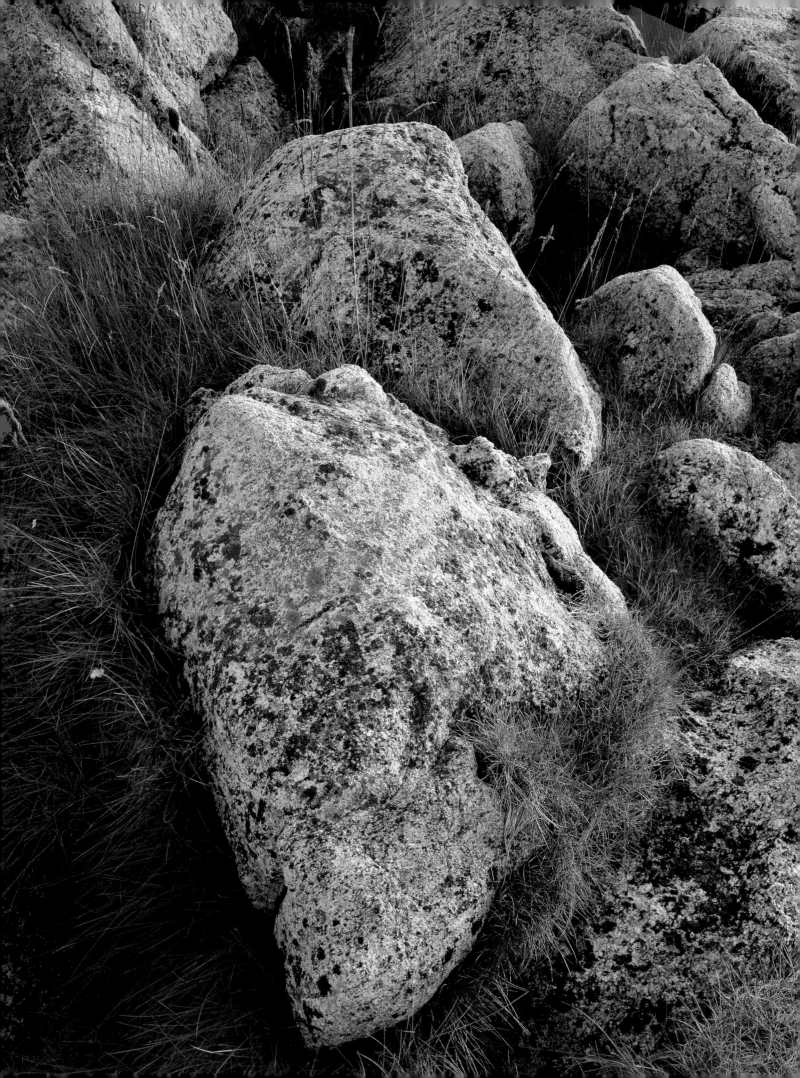

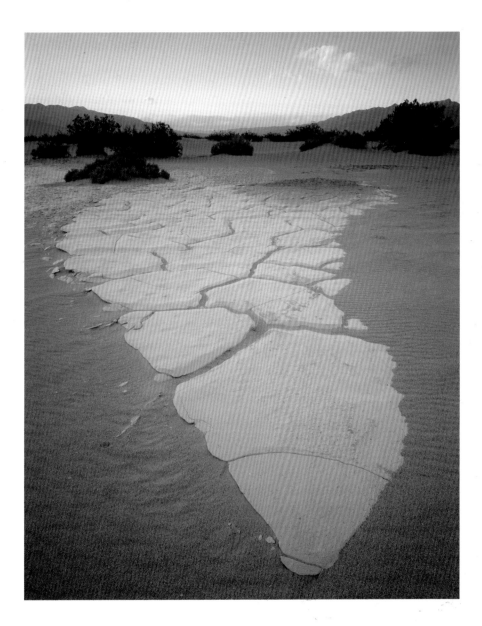

Dried lakebed, Death Valley
California

Sommarøy
Norway

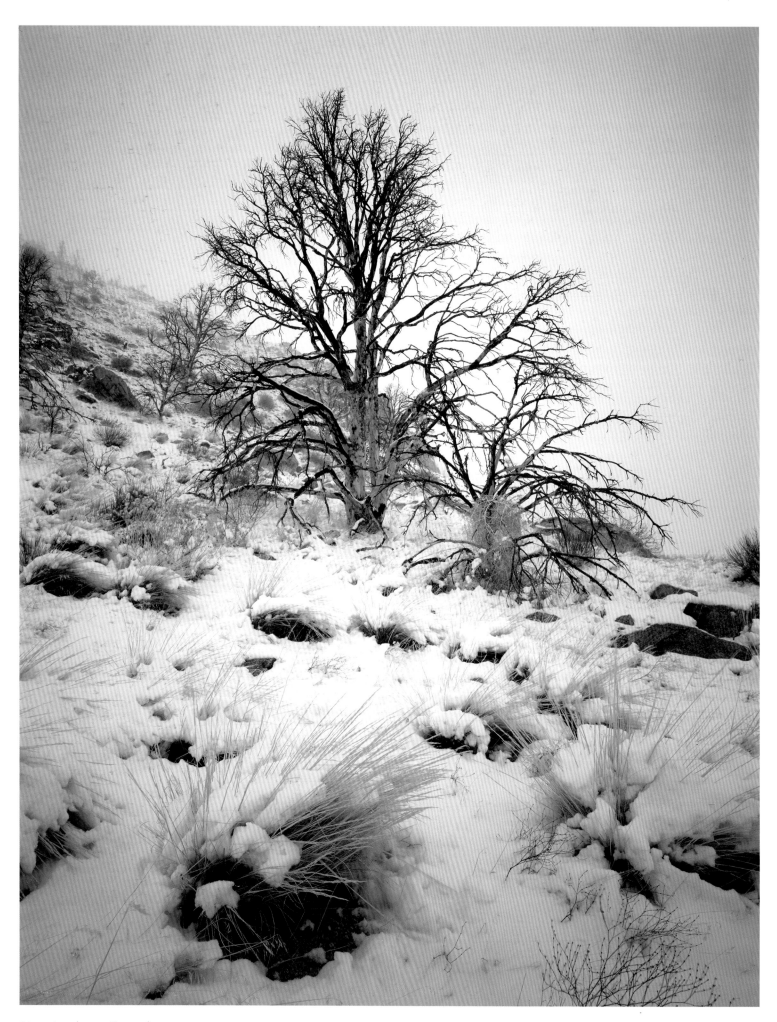

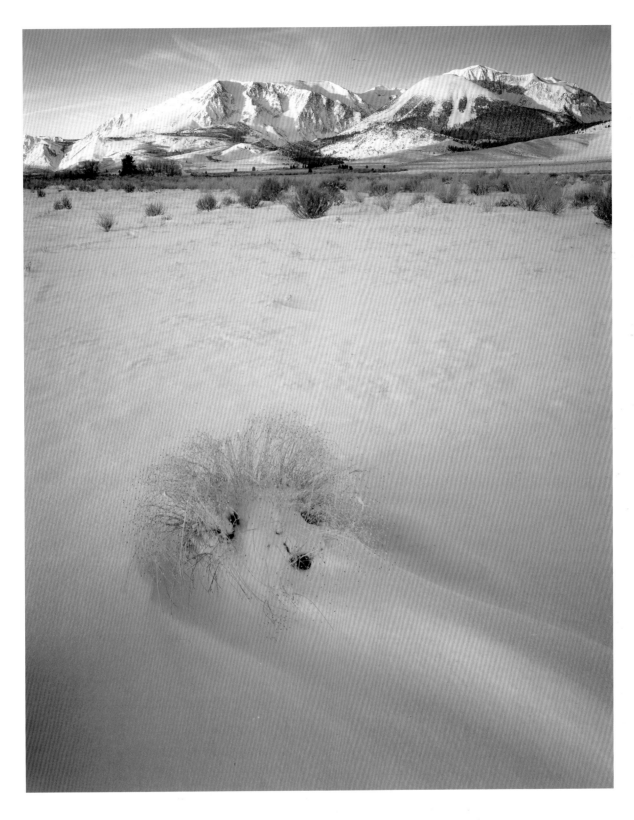

Near Lee Vining
California

Burnt forest, Highway 395
California

when they encounter it. A brush with beauty, however personal or universal, has a powerful effect upon viewers. They are able to relate more intimately to images that contain it. Of course, recognising beauty does not mean that we can describe it in words. The fact that you can't quantify beauty makes it richer rather than poorer.

American photographer Robert Adams (no relative of Ansel) suggested that we judge art:

> . . .by whether it reveals to us important Form that we ourselves have experienced but to which we have not paid adequate attention. Successful art rediscovers Beauty for us.

He also wrote:

> . . . the Beauty that concerns me is that of Form. Beauty is, in my view, a synonym for the coherence and structure underlying life. . . Why is Form beautiful? Because, I think, it helps us meet our worst fear, the suspicion that life may be chaos and that therefore our suffering is without meaning.

Beauty for Adams is a universal concept that lies at the heart of what photographers are seeking to do when they create.

The beauty that Adams and Stieglitz envisage isn't the shallow veneer of appearances, it's not at all the anodyne decorative quality celebrated in beauty contests. It isn't absolute: there isn't a quantifiable highest, widest or deepest point in beauty. So how can anybody even think of having a contest? Beauty is relative, it's a quality not a quantity, and some will find it in a particular image while others will not. But the beauty that Adams refers to isn't simply a question of aesthetics. Rather it is a deeper expression of beauty that not only contains the superficial visual appeal but, critically, also reveals truths about our world. A photograph with this quality makes you see something fresh again or more importantly reveals something that you had never noticed before.

Images with this quality might be sumptuous or terrifying, they might make you happy or move you to tears. Whatever emotion they instil, the images will be compelling; beauty will force you to look at them. It is perhaps this attribute of beauty that best helps us to confirm whether it is present in an image. And isn't this what

Achnahaird
Scotland

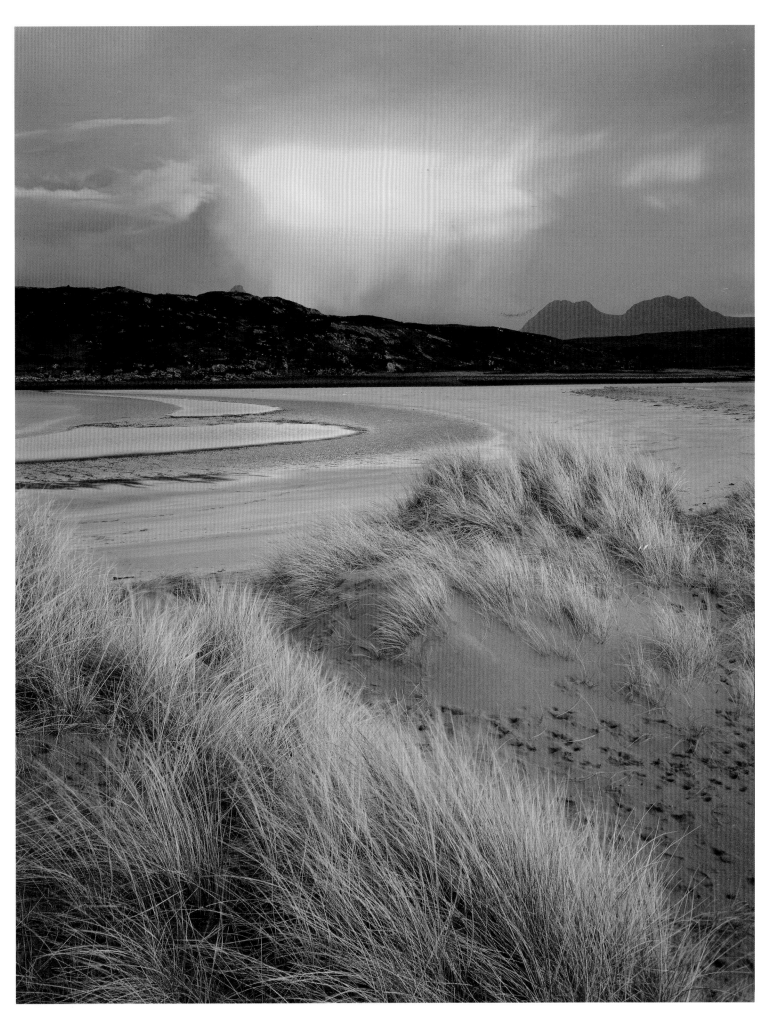

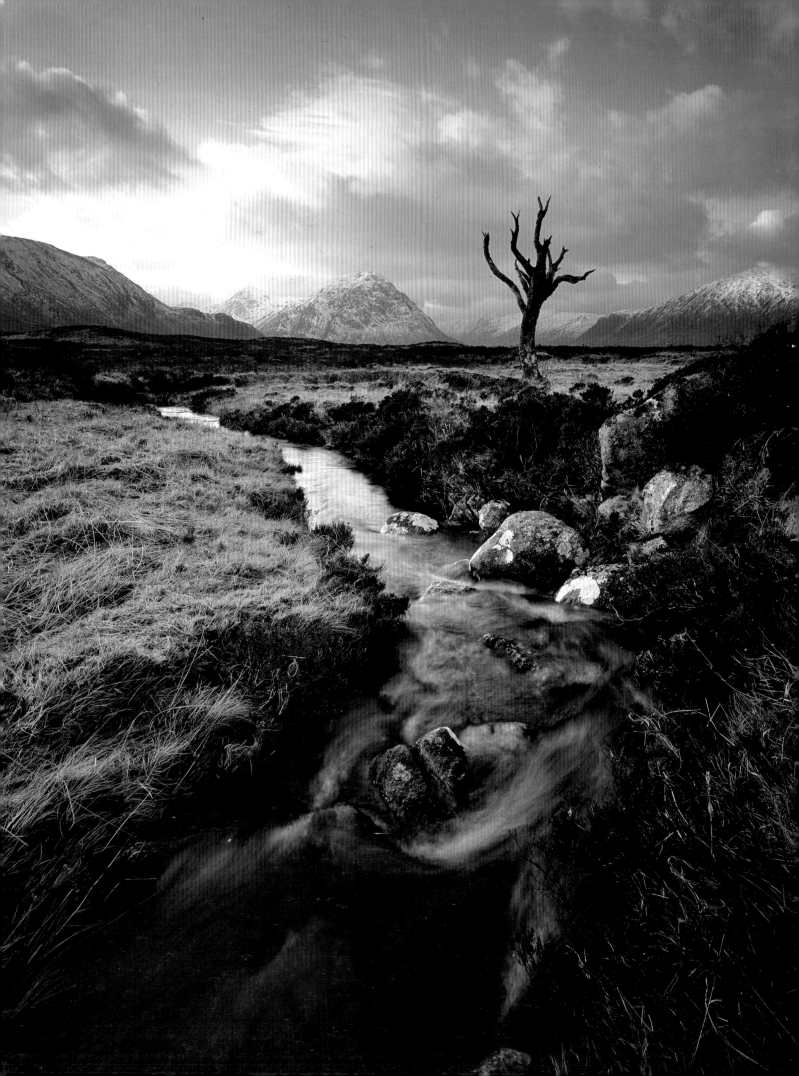

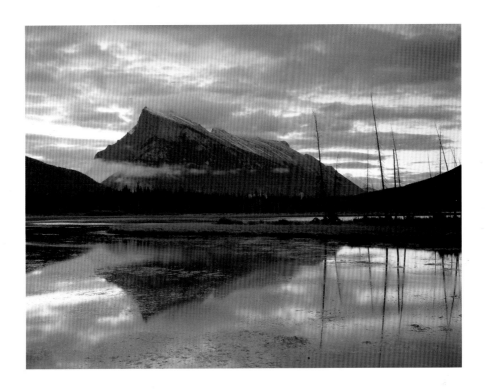

we all want from our images? We want people to take notice of our photographs because we are passionate about our subject and we have something to say.

It seems ironic to me that beauty, which humans crave in so many aspects of their lives, has been considered with disdain for almost a century within much of the realm of high art. From the early twentieth century onwards, the view put forward by over-eager Modernist artists was almost precisely opposite to that expounded by Adams and Stieglitz. In the Modernist view beauty really is only skin deep – a matter of shallow (in all senses of the word) appearances, a matter of taste and, as they sneeringly point out, inferior bourgeois taste at that! Of course there have always been exceptions but here I am discussing the entrenched orthodoxy that has formed so much of the art establishment.

The Modernists sought to apply scientific principles to art. Rather than seeing art as an aesthetic pursuit they sought to make it purely intellectual to make it *an– aesthetic*. Of course an-aesthetic just makes you numb and I don't want art to numb my senses. You might say that they were merely following the social trend.

Rannoch Moor
Scotland

Mount Rundle, Banff
Canadian Rockies

In our increasingly secular Western world, we more often place faith in scientific rigour than in what we dismiss as touchy-feely notions such as beauty. However, it is only poor scientists and their imitators who hate ideas that they can't quantify, preferring absolute values to relative ones.

As modern art became increasingly inward-looking over the last century and almost completely turned its back on the natural world, so it increasingly became separated from common experience and its popularity plummeted. What more common experience do we have than the planet we live on? The problem seems to be that the most vociferous, and therefore in the eyes of the media the most influential, modern artists live along with their critics on planet Art. I use `critics' with some unease as they seem more like apologists. This is an urban world that has a very rarefied atmosphere divorced from nature. Over half a century ago Edward Weston wrote in his daybooks:

> It seems so utterly naive that landscape, not that of the pictorial school, is not considered of `social significance' when it has a far more important bearing on the human race of a given locale than excrescences called cities.

So true.

To dismiss natural beauty as a source for art merely on the grounds that it isn't new is ridiculous. It is clear to me that many modern artists, especially conceptual ones, are now scraping the bottom of the barrel. The continuous search for novelty has led them into an artistic dead end. It is perhaps worth repeating the words of architect Antoni Gaudi, 'Originality is to return to the origin.' Nothing is closer to the origin than the natural world. The natural world is held in common and offers a much wider realm than the actions of mankind. It surely can't be true that art has exhausted the possibilities for exploration and expression encompassed by the planet around us. I believe that there must be room for a middle path between the self-obsession of Modernism and the Marxist directive for art to concentrate on the social world. Surely these are just different forms of anthropocentrism, both equally and mistakenly self-centred. What's wrong with art looking at the natural world? Not the capitalised, mystical Nature celebrated by Ansel Adams et al. but simply the environments that gave birth to humanity.

Proponents of high Modernism fear beauty because it may swamp their logic. They fear that it will beguile the viewer into accepting a lie. From their stance beauty is

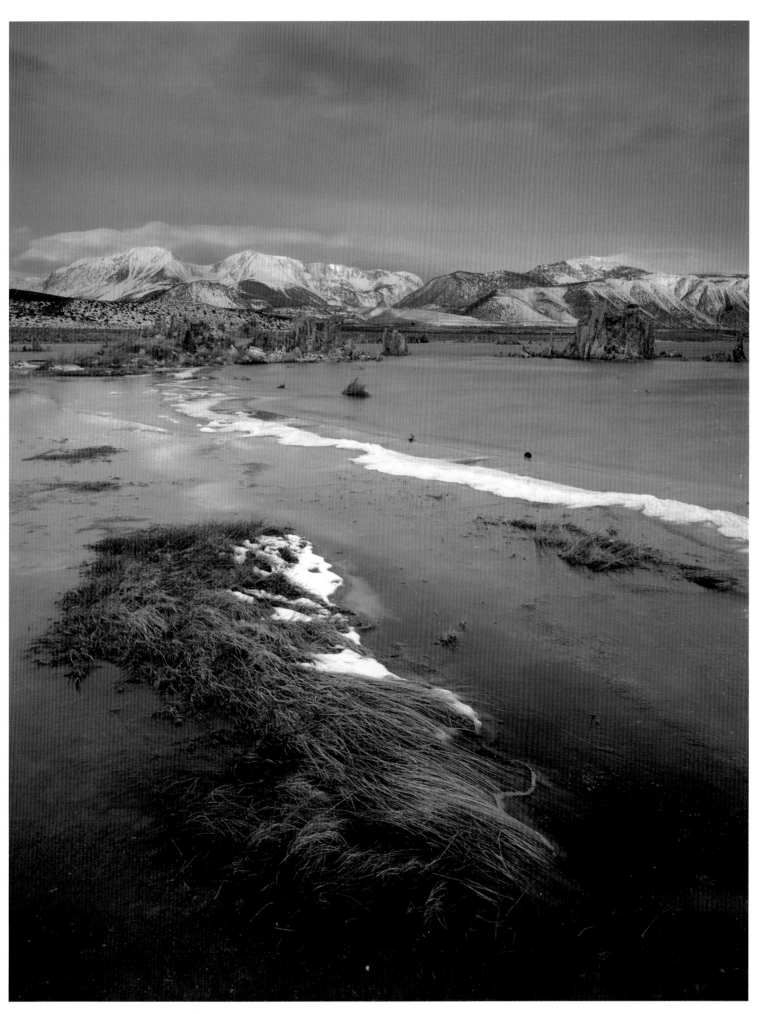

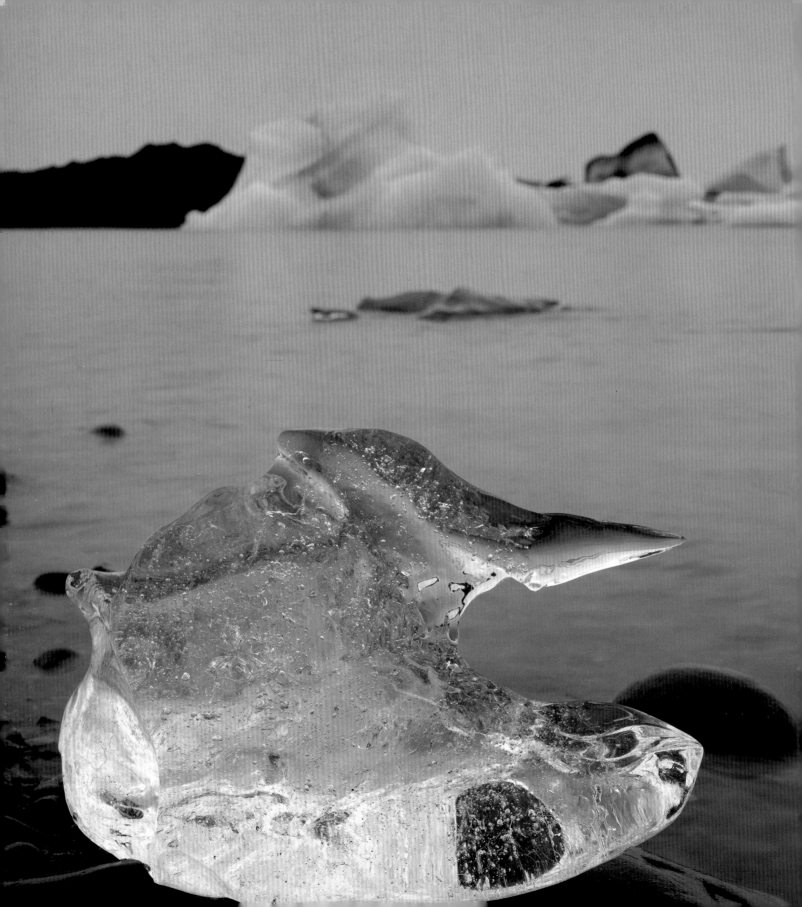

something that clouds the vision, something that obscures or, at best, elaborates upon the truth. If beauty is untruthful then the obverse must be true of ugliness, seems to be the `logic'. Anything ugly then takes on an unimpeachable authenticity. We can see the effect of this dominant philosophy in the art photography market, where the deliberately cold, drab and enervating work of photographers such as Andreas Gursky is not only highly praised but also the most economically successful photography of today. David Lee, writing in *Ag magazine*, noted:

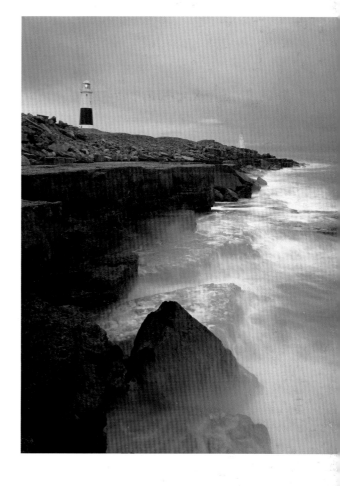

> Self delusion abounds in all walks of life…
> there is a universal belief, taken as read, that
> Andreas Gursky is a great living photographer
> but on the visual evidence alone, without
> reference to price tags, size and the
> promotional rhetoric of his galleries and doting
> critics, there is nothing to support this view.

We might usefully ask why Gursky's work fails to persuade Lee at a visual level. I think it is because the work doesn't evoke an emotional response. His images are illustrative rather than transcendent. The concept may be exciting but the execution is dull. Isn't it important for the visual arts to stimulate us visually?

For many Modernist and Postmodernist artists the manner of representation is more important than the subject – the intellectual has taken precedence over the visceral, the emotional and the decorative aspects of the image. An ugly image is seen as intellectually more successful than a beautiful one, almost irrespective of its message. This is a clear case of the triumph of style over content. In other words just what the over-eager intellectuals were seeking to avoid in the first place.

Beauty is a rare quality in our everyday lives and we hunger for it but does this mean that it will necessarily deceive us? Are we all so callow as to be overpowered by its simple presence and not to seek other levels of meaning in an image? Clearly for some this will be the case. But surely those who rail against beauty are those least

Jökulsárlón
Iceland

Portland Bill
Dorset

Gneiss pebbles, Isle of Lewis
Scotland

Abandoned boats, Achiltibuie
Scotland

likely to be swayed by appearances, those best equipped to find deeper meanings? David Lee went on to write:

> I wish sincerely that someone would explain [Gursky's] genius to me because I'm damned if I can see it or, more importantly, feel it.

This last point is for me the most telling: we should feel something other than disdain or boredom when we experience art. For me, one of the most important criteria for a good work in painting, sculpture, music or photography is that it should evoke an emotional as well as an intellectual response. Interacting with works of art should make our heart beat faster, make us feel sad or happy or wistful or depressed or whatever. . . Just make us feel!

The response might be pleasant or unpleasant but it should arise directly from the piece. The problem for all visual artists, and this applies to musicians too, is that there is no guarantee that others will feel as the artist does about their work. The emotions or concepts that the photographer is trying to convey might pass the audience by because there is no fixed meaning for a single image. Much modern art has got around this philosophical impasse by grafting on an external support structure, by explaining the imagery with words. This approach directs the viewer's interpretation more surely but also makes it more firmly an intellectual rather than an emotional experience. For my money I want art without the need for art-speak. I want my initial response to be visceral not cerebral. Intellectual enquiry can follow on but it shouldn't be to the fore.

It might seem like the pot calling the kettle black for me to accuse intellectuals of diminishing the power of art. I sincerely believe that art can blend the intellectual and the expressive but that the image should appeal to our visual and emotional senses first and foremost. The image should stand or fall on these criteria alone. Not everyone will get what the artist means but that's life! Artists will almost inevitably acquire a philosophical viewpoint on the process of making art and the messages they are trying to convey but the general audience should not need to know this in any detail in order to be excited by the images. The necessity for words just shows how badly some artists have failed. I find myself in agreement with Charlie Chaplin, who opined:

> I do not have much patience with a thing of beauty that must be explained to be understood. If it does need additional interpretation by someone other than the creator, then I question whether it has fulfilled its purpose.

Landmannalauger
Iceland

Successful photographs, and I mean by this ones that have received both popular and critical acclaim, seem to contain some secret ingredient that is universally, if imperfectly, understood. Might this ingredient be beauty? Fred Hutchinson wrote in a critique on Postmodernism:

> The postmodern arts establishment has not been able to entirely snuff out beauty. Oddly, beauty has a toughness and durability which the more fragile realm of ideas seems to lack. People still listen to Beethoven, admire Michelangelo, go to Shakespeare plays, and read Keats.

As beauty has such a strong appeal is it not likely that some universal and fundamental response underlies our experience of it? Might it not be an innate response to an aesthetically presented truth? A possible link between beauty and truth and between the particular and universal aspects of beauty is suggested in recent psychological research. It used to be thought that our higher brain functions, such as language and logic, were simply functions of the cerebral cortex: the grey, wrinkly, squidgy bit that we picture when we think of brains. Sitting beneath the cortex is a region of the brain known as the limbic system. Conventional wisdom held that this part of the brain was older in evolutionary terms and therefore less sophisticated than the cortex. The limbic system is involved in emotional responses to stimuli and also in powerfully linking those responses to memory. It is this part of the brain that instantly conjures up strong memories associated with stimuli and particularly with smells, perhaps transporting us back decades to when we last experienced the particular aroma. It is also responsible for the classical emotional responses to colours, such as associating yellow with warm and blue with cold. There is a conjecture that this colour association relates to our cold-blooded reptilian ancestors, who would have found the yellow light of warm sunshine much more appealing than the blue light of the shade.

Evidence now suggests that the limbic system in the human brain plays a far greater role in the synthesis of ideas than had previously been thought. As well as assessing sensory information and motivating the appropriate emotional response it also acts as the central switchboard for information from higher brain functions. Information being passed from one region of the cortex to another is modulated by the limbic system. It plays an integral role in this exchange and not only influences its outcome but also appends an emotional response to it. The limbic system thus not only makes human intelligence possible but also forms the bridge between emotions and objective thought. It is the limbic system that provides us with the capability of

Achnahaird
Scotland

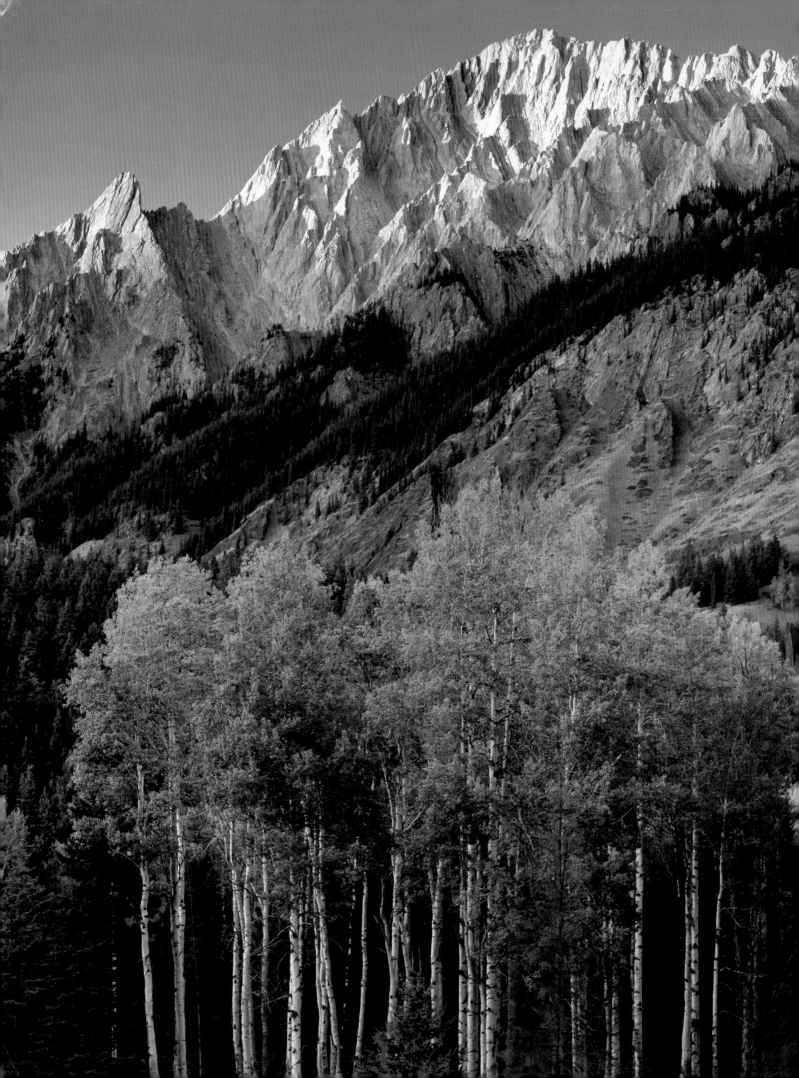

reasoning so that we may solve problems and also provides us with the feeling that good solutions are beautiful. This makes perfect sense in evolutionary terms. Finding something that works beautiful is a rewarding experience and one that is likely to lead to positive outcomes for the individual. This explains why the mathematician Henri Poincaré wrote, 'the longing for the beautiful leads to the same choice as the longing for the useful'. It is also why Subramanyan Chandrasekhar, a winner of the Nobel Prize for Physics, wrote, 'What is intelligible is also beautiful'.

All well and good, but how does this relate to photography? Beauty is at the heart of expressive photography because it binds so many aspects of image-making together. When we manage to distil our passion into a harmonious arrangement, beauty links the emotional response of the photographer to solving the problem of composition. It also links the individual beholder (the particular) with the audience (the universal); when individual fascination achieves a wider significance it may also reveal truths hitherto untold. And all in an aesthetically appealing package, what more could one ask for?

The title of this chapter was a response to Modernism's an-aesthesia and a plea to turn our back on its coldly intellectual take on art. It isn't smart to spurn beauty, it doesn't help us see more clearly; it just makes art uninspiring. I now realise that beauty never really went away. It lies at the core of our humanity and cannot simply be ignored.

Beauty itself doth of itself persuade
The eyes of men without an orator.
William Shakespeare

Mount Ishbel
Canadian Rockies

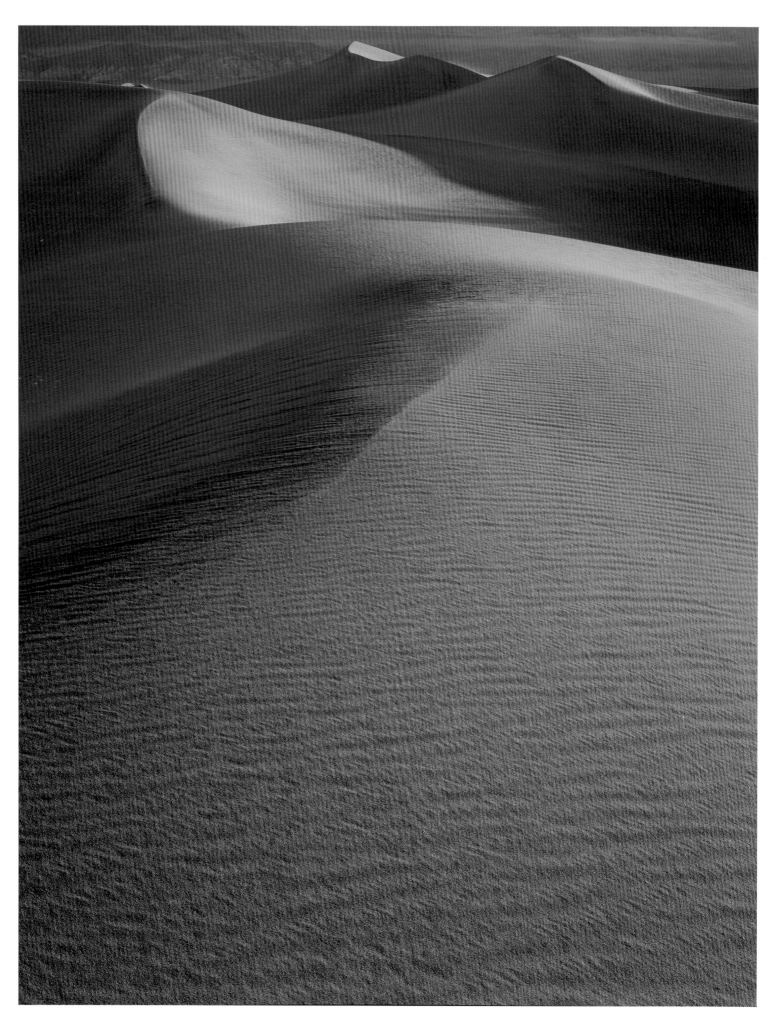

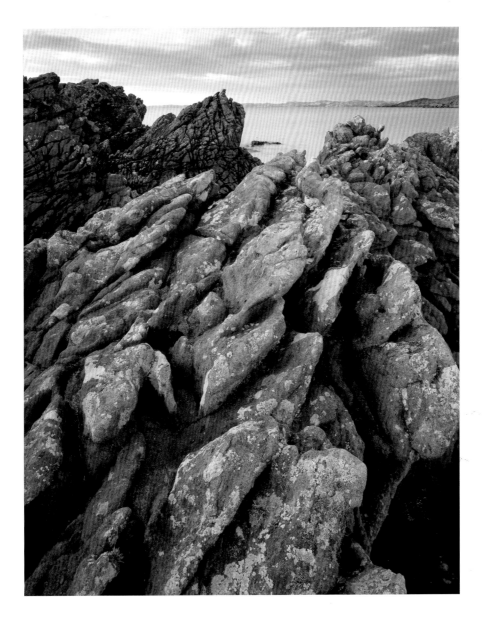

Achnahaird
Scotland

Mesquite Dunes, Death Valley
California

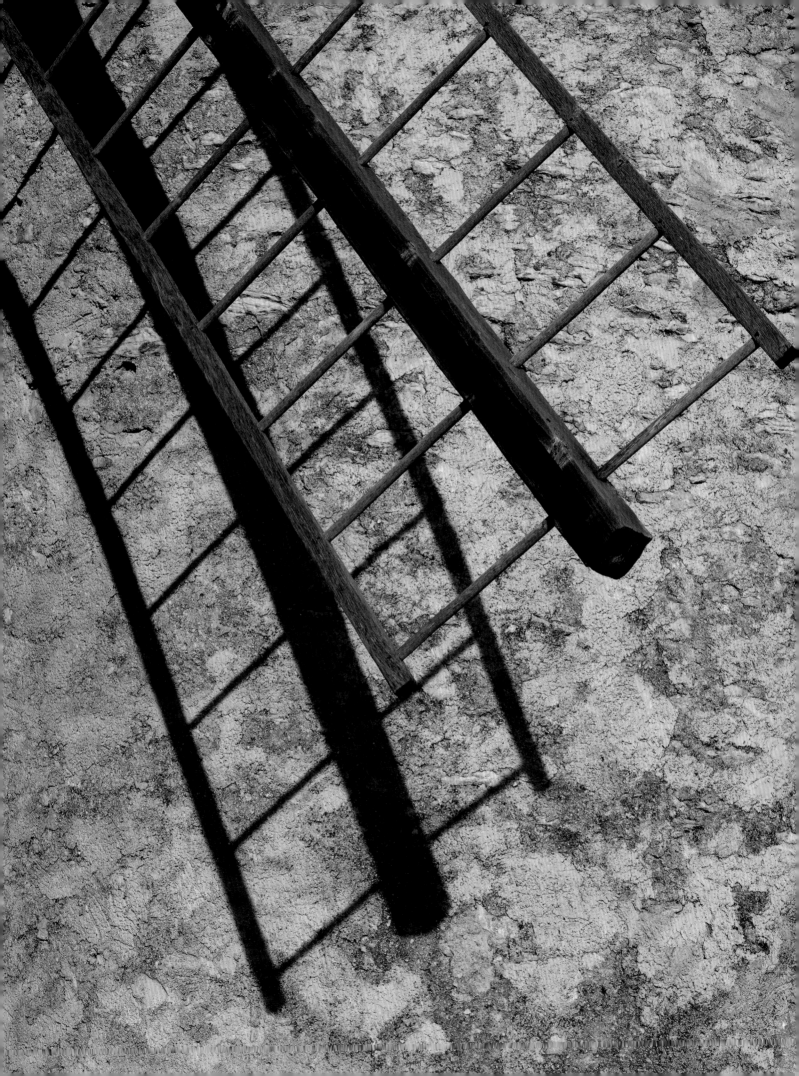

QUESTIONS OR ANSWERS?

Confidence, like art, never comes from having all the answers; it comes from being open to all the questions.
Diogenes Laertius

The previous chapters have dealt with various attributes of a photograph's content but in this chapter I want to turn my attention to photographers and examine questions of their intent. In my introduction I ironically proposed that 'Location, location, location!' could be adopted as the motto of landscape photography. It is apparent to me that landscape photographers have an unhealthy obsession with just where an image was made. Indeed, one of the criticisms levelled at my first book was that I did not disclose this information. From talking to people on the workshops that I lead I know that this desire to know just where an image was made is very deeply felt. Some suggested that I was being protectionist – that my intention was to hide an image's location in order to stop others repeating it. I can assure you that this was not the case: I am happy to reveal the location of any image. My motive for not doing so in the book was simply that I wanted each image to be studied and appreciated on its own, devoid of any connotations arising from an individual viewer's knowledge of its place of birth. In my opinion, where a landscape image is born is considerably less important than how it was conceived.

For me, it is a given that landscape photographers should be more concerned with the fall of light on the land than the land alone. In other forms of photography – and I am particularly thinking of reportage – the light is not often as important as the form. But in landscape we seek to capture an ideal confluence of light and land. Our passion springs from the forms of the landscape but these forms alone are rarely enough. A photograph of the land without the resonance provided by sympathetic light can provide us with little more than a record. The ideal confluences I speak of are rare and quite often serendipitous. The photographer must be ready in order to make the most of them. In other genres,

the subject is transitory, in landscape the subject appears to be solidly rooted, at least over the short span of a human life.

This apparent immutability gives some photographers the false hope that they might repeat, or even better, a famous image made at a particular location. However, a landscape photograph draws its power in part from the unstable and dynamic relationship between the fall of light and the solid geography. This relationship makes it *very* difficult to create the same image on two separate occasions. Of course, the other important aspect of a photograph is what it evokes about the subject. A great photograph's power is the product of light and composition. This might be called the photographer's voice. Repeating the composition of another, even if the light is different, pointlessly repeats what has already been 'said'. It is mere mimicry. Photographers should strive for their own voice, strive to say something genuinely different about the place in their *own* way.

It is important to state that I am not against a photographer re-working his or her own compositions. This is something that I occasionally do myself. Many of the images that I make are what I refer to as record images or work in progress. In these images, either the conditions were not ideal or I am unhappy with my interpretation of the subject. I often learn lessons from these first images upon which I may build a 'finished' work. I may also revisit a location where I have made a successful image in different conditions in order to produce a different interpretation. This will typically be a different composition as well because I find it hard to repeat my own compositions, never mind somebody else's.

Photographs are necessarily always *of* the world but if we want to move beyond illustration they must evoke emotional responses that are not bound to a particular place. A famous place is weighed down with unavoidable and often unwanted connotations. You may make a view of such a place that is atypical, that is perhaps even unrecognisable, but as soon as you name it the image is burdened with all that has gone before. The image may be admired for its novelty (though it may also be criticised for this!) but it can never completely escape from its predecessors. In an anonymous place the photographer is more likely to be free of the unwanted connotations that arise from images of iconic locations. Another obvious problem with photographing any of the honey-pot locations from standard viewpoints almost one hundred and seventy years after the birth of photography is that one can guarantee that someone else has made a better image there in better light. The question then arises, why should you bother to make an image of a famous

Badwater, Death Valley
California

place? Is it not a waste of pixels or silver halides? Let's consider the worst-case scenario. I remember visiting Peyto Lake in the Canadian Rockies, a truly remarkable turquoise jewel backed by towering snow-capped mountains. A steady stream of Japanese tourists was arriving at 'the viewpoint' – in essence where the designer of the walkway had chosen for people to stop and take a photograph and hence built a broad wooden platform. After uttering the words, 'Ai cheese!' each took an image of their loved one in front of 'the view'. No time was 'wasted' communing with Nature, no time spent on finding a novel viewpoint. Within ten minutes they were back on the bus and off for pastures new. Okay, this is an extreme example and they weren't photographers. But there is a tendency, even amongst those who consider themselves landscape photographers, to make an image just in order to prove that they've been there – the visual equivalent of Munro bagging, 'Been there, done that'. This is fine if all you desire of the image is that it be a sort of aide-mémoire.

Let's set this libellous suggestion to one side and ask why else one might photograph the great view. Might it just be to explore the photographic possibilities for yourself? Humans learn best by example, so travelling to the famous view and making an image might teach you something about how other photographers have solved the complex problems of composition in that place. This habit of learning from the efforts of past masters is an entirely honourable tradition. Many have spoken of standing on the shoulders of giants, of their achievements being possible only because of those who have gone before. The key is to use what you have learnt merely as a stepping stone on the way to finding your own voice. The original should act as an inspiration, it should be the launch pad for a new flight of discovery. It is all too easy to produce endless empty pastiches of other photographers' work unless we treat image-making in this way. A quick flick through the camera press will show how many have sadly failed to learn this lesson.

On a recent workshop a participant showed his portfolio of a dozen or so perfectly executed landscape images. The only problem was that they weren't his images – they were technically excellent copies of another photographer's compositions, often shot in the same lighting conditions and season as the original. I asked him why, when he was obviously a competent photographer, he was repeating another person's work rather than making statements of his own. His answer was that he had very little time for photography, which he had to fit in between work and family commitments, and that he needed to be sure that he would be able to make an image when he ventured out. This, for me, is no reason at all and I quizzed him

further. He eventually admitted that he was afraid that he would fail to discern a composition in the short time he had available. He simply lacked the confidence to trust his own judgement about what was and wasn't a good image. So, he had not unreasonably sought guidance from published images. As an aside, it must be remembered that the mere fact of publication isn't always proof of quality. Magazines, for instance, need images to fill their pages every month and their criteria are therefore not always of the highest standard. The problem was that he was practising his photography by rote rather than understanding anything about the underlying principles and using that knowledge to make his own images. There is a happy ending to this story as by the end of the workshop he had gained the confidence to begin making his own explorations of the landscape.

Why else might we make an image of a famous location? Might we feel that there is genuinely something new to be revealed and that we are the ones to do it? Of the reasons I have looked at so far this has the most merit, and there is *just* an outside chance that you may succeed. I am not suggesting for a moment that this isn't a worthy ambition but I would remind you that the weight of connotation associated with a famous view means that one would need to possess remarkable insight in order to produce something truly new.

The preceding discussion might seem a little depressing but don't despair, there is hope. I want to show that in a world saturated with photographs great new images are more likely to be made somewhere anonymous rather than somewhere famous. The very fact that a great image already exists of a particular location should mean that we treat that place with circumspection rather than flocking to it. Great photographs may be a sign that a well-known location has great creative potential but they may just as well be a sign that the seam of potential has already been exhausted. Some of the most memorable images have been made from viewpoints where only one photographer may stand and frame the ideal alignment of elements. As latecomers we are unlikely to better an image of such a spot and any attempt is likely to be both disheartening and futile.

I have carefully chosen the word anonymous to describe my ideal kind of location, not merely as a synonym for unknown but also to suggest an unassuming place. It has been my experience that my best images were made in quite ordinary places. As a landscape photographer I obviously don't mean the local supermarket car park but quiet, wild places. The intent of many landscape photographers is to make an image of somewhere extraordinary; mine is to reveal the extraordinary in seemingly

Þingvellir
Iceland

mundane wild places. It is relatively easy to make an exclamatory image, in places such as Bryce Canyon or Yosemite, which shout at you, and it is a simple matter to pass this loud message on to the viewer. It is much harder to make an image that is contemplative. In order to do this we need to learn to look very hard at the landscape so that we once again see wonder in the commonplace.

Although I have taken images since 1979 I don't feel that I became a photographer until 1999. I attribute this change in status, this graduation, to changing from being a 'taker' to a 'maker'. The taker merely records reality whereas the maker uses reality as his or her raw material but tries to fashion something new out of it. I can more or less pinpoint my transition from one to the other. It was the day when I created the first abstract landscape image which I felt fulfilled my expectations. It was also the first time that I had consciously seen a part of the landscape as an abstract rather than just a detail; the first time that I had knowingly sought to evoke more than a simple description. Why was this image such a revelation to me? The answer is to do with my intent and also, in a way, to do with the possible differences between a detail and an abstract.

The detail is typically an illustration of a small part of the wider landscape, and its ambitions are limited to describing some noteworthy portion of reality – for the photographer but not necessarily for the rest of us – in a forthright, unambiguous manner. It is therefore unlikely to pose many questions to the viewer. The abstract, on the other hand, typically possesses at least one of the four mysteries that I referred to in the second chapter. It doesn't seek to provide answers; rather it forces the viewer to ask some questions of the photograph and photographer:

> What am I looking at?
> Why did the photographer make this image?
> Why did the photographer choose to compose it like this?
> How does this make me feel? Unmoved? Curious?

Now, these aren't hard and fast rules. A simple portrayal may, through quiet contemplation, evoke questions rather than merely illustrate but this requires subtlety and a sensitivity for nuance from the photographer. A loud image, a brash approach with super-saturated colours, drowns out any such delicate questions. They simply become lost in the background noise. The denotative power of the photograph can swamp subtle questions but simplification will help to concentrate the viewers' attention. As Shakespeare said, 'Truth hath a quiet breast'. Ask questions,

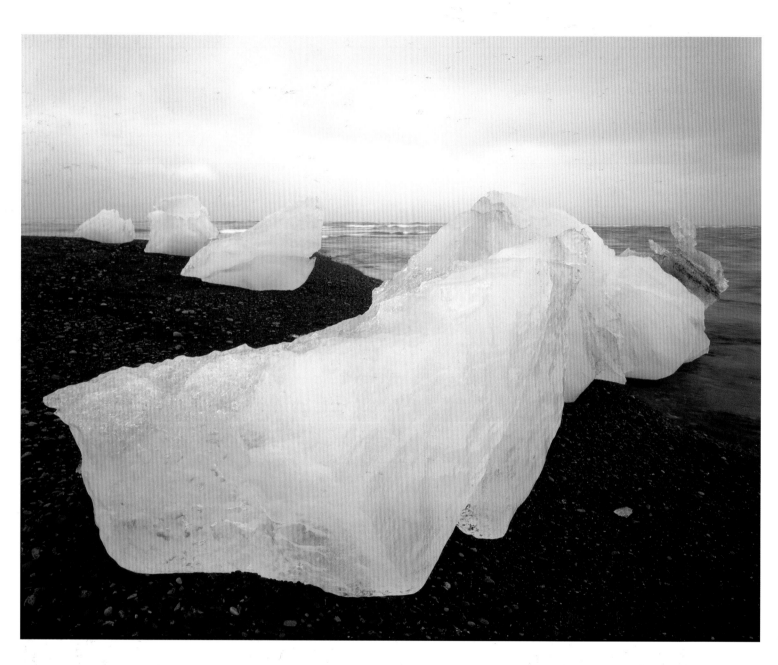

Near Jökulsárlon
Iceland

Vikspollen
Norway

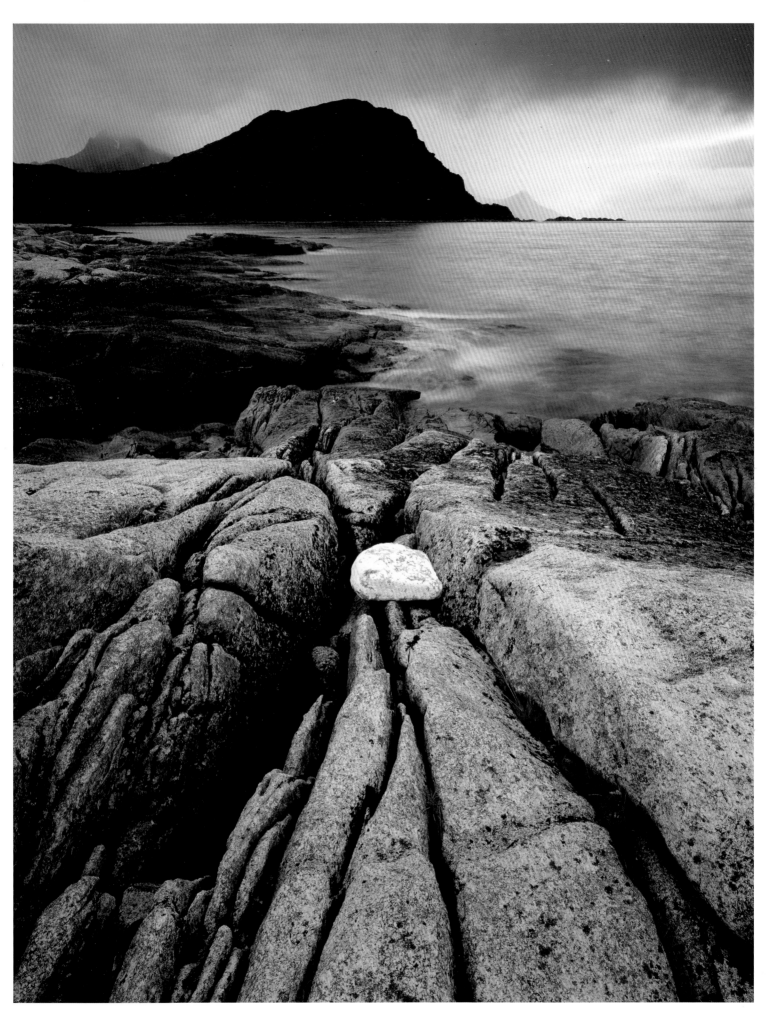

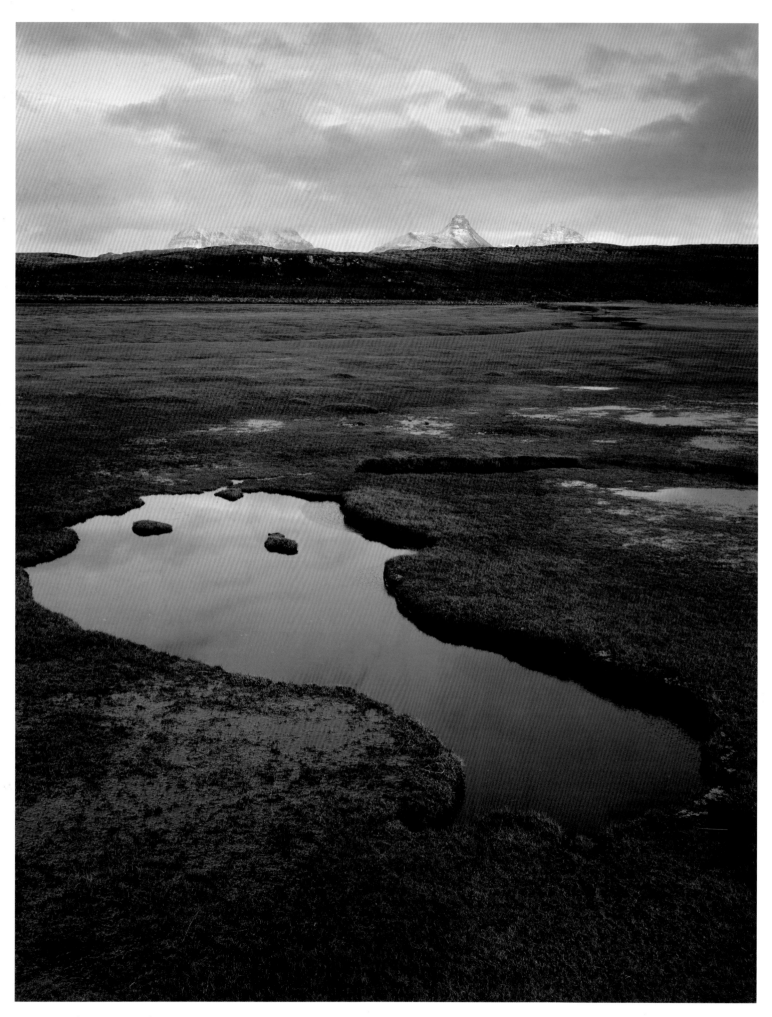

make your images simple, make them quiet and you may, at the very least, reveal some further mysteries to explore.

A questioning image is more 'difficult' to view because the viewing requires the active participation of the viewer. Most photographs are viewed passively; we absorb what they show without much conscious effort. But, in the same way that junk food is pleasant to eat – because it gives an intense but short-lived high – these passive photographs rarely leave a permanent impression on us. An hour, or at most a day, after we've looked at a passive image it is lost to our memory. What we get out of photographs is directly linked to the effort that we put into the viewing and it seems clear to me that the photographer's duty is to try and engage the viewer – not simply by making 'pretty' images but by asking something of them in return for the gift of the image. The viewers should sing for their suppers.

At a recent photography fair I became engaged in conversation with a charming man named Ian Biggar. Of the many things we discussed one anecdote stuck in my mind. He described a conversation he'd overheard on a photographic workshop. The leader had asked a participant 'What are you trying to say in your image?' The participant replied, 'I'm not sure I am trying to say anything yet. I guess I'm still listening.' This struck me as a very sound basis for photography. When I am working I try to be open to the possibilities for image-making rather than having a fixed outcome in mind. What's important to me is that I am making an enquiry about my surroundings in my images rather than imposing a conclusion. I am not seeking to make definitive statements because I don't know the answers. The questions vary enormously from image to image; I might be asking about the colour of light or what is it that is beautiful about moving water or why I find that arrangement of elements interesting. These questions are born as personal enquiries but achieve maturity only if their final form appeals to a wider audience. The important thing is never to stop questioning. Those who 'know' all the answers have stagnated. In the words of a Chinese proverb, 'He who asks is a fool for five minutes, but he who does not ask remains a fool forever'.

It seems to me that we might usefully think of all photographs as always being either questions or answers.

Questions
Images that are questions invite us to explore what we feel about the image's subject. They evoke questions without necessarily providing answers and they tend

Achnahaird salt flats
Scotland

to be open to interpretation, to be ambiguous. Questions can be both aesthetically pleasing and revelatory. Questioning images don't attempt to tell the whole story, they are content to be merely an enquiry.

Any photograph made with serious intent is a form of enquiry: its author is asking a question or questions of the world. This may be as simple as seeking the answer to the problem of composition but it may well be a deeper question. The crucial point is that sometimes these questions are answered within the frame and sometimes the image just leaves them unanswered. It is important to state that I am not talking here about the question of composition being unresolved. An unresolved image is one that lacks compositional balance and is aesthetically unpleasing: it is such an ill-posed question that the viewers are not only unsure what they are being asked but are unsatisfied with the form of the image that they are being presented with.

Answers

Images that are answers impose the viewpoint of the photographer upon the viewer. They appear to be straightforward, to be merely illustrative, and tend to provide a definitive answer without provoking the viewer to raise any question. Answers can be aesthetically pleasing but are never surprising. Photographers who stay in their comfort zone will make answers. They will typically shoot similar subjects in a formulaic way. They are giving pat answers to the questions posed by the subject matter or are not even aware that any question exists. A typical seaside postcard would be a good example of an answer image. An answer shows us what was photographed but doesn't invite us to think: it denotes far more than it connotes.

I am by no means the first to propose such a duality as a way of classifying images. The most obvious example is the objective/subjective dichotomy, an argument that has running since the invention of photography. Photographer and museum curator John Szarkowski proposed another in 1978. He held an exhibition entitled 'Mirrors & Windows at the Museum of Modern Art in New York that has greatly influenced subsequent ideas about the interpretation of photographs. The premise for the show was that all photographs are either mirrors reflecting the photographer who made them or windows presenting the photographer's view of the outside world. The former tell us more about the photographer than about reality, and the intent of the latter is to tell us more about reality than about the photographer.

The difference between Szarkowski's classification and mine becomes more apparent if we look at a diagram.

Poverty Flats
Northern Arizona

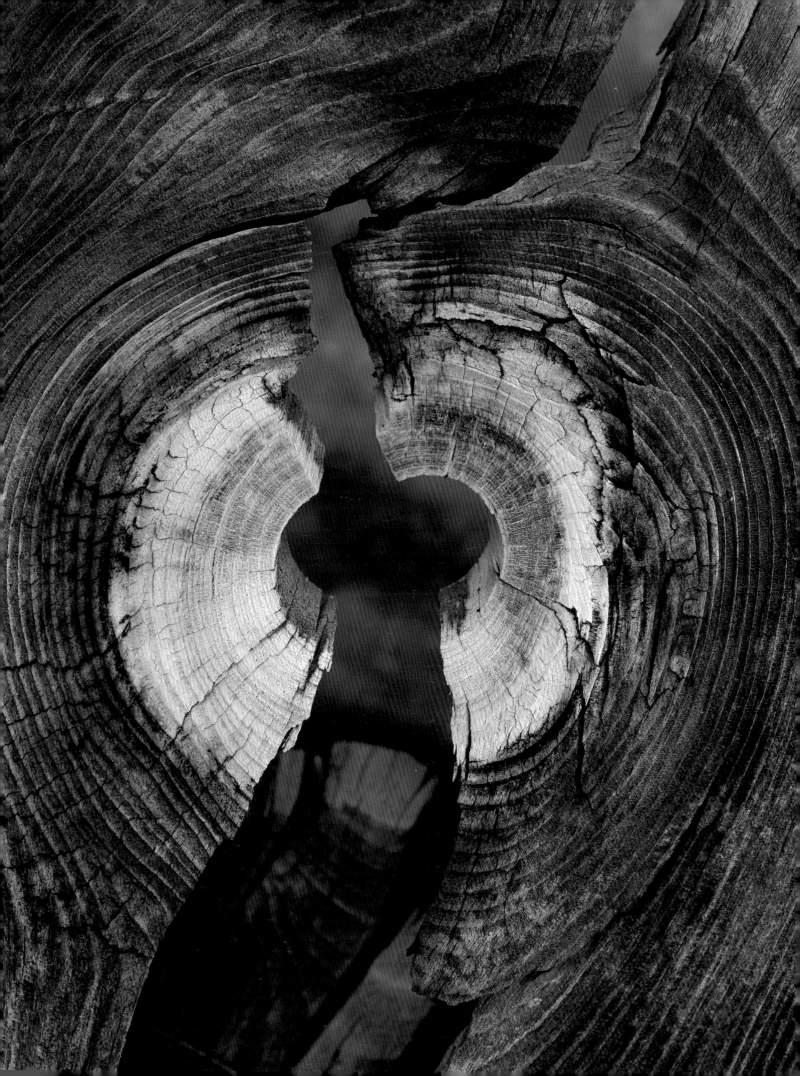

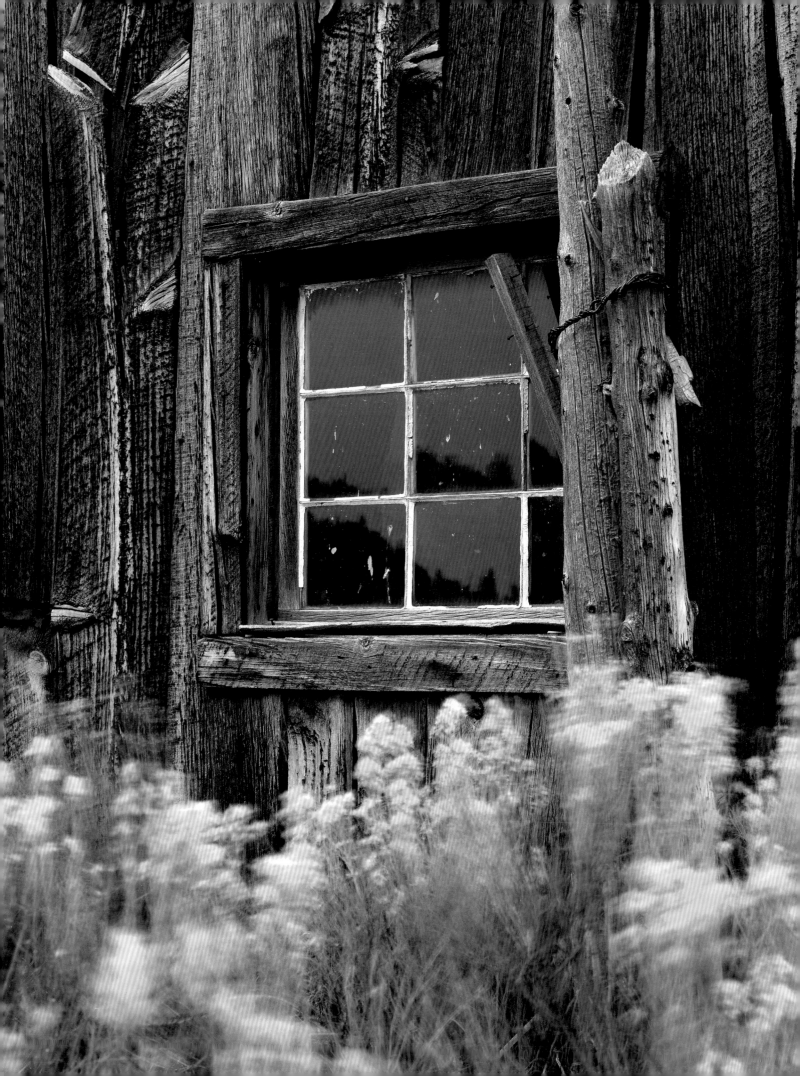

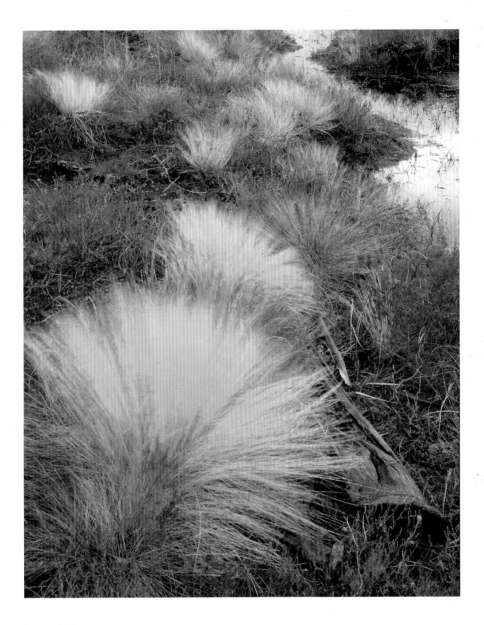

Rannoch Moor
Scotland

Abandoned farmstead, Hatch
Utah

Mirrors	**Windows**
About the photographer	About the world
Open to interpretation	Illustrative
Questions	**Answers**
About the world	About the photographer
Open to interpretation	Illustrative

You'll notice that the new categories mix the attributes of the old: a 'question', for example, has one of the attributes of a 'mirror' and one of a 'window'. I am not suggesting that Szarkowski's analysis is incorrect, merely pointing out that we might look at photographs in another way.

Vattarnes
Iceland

What benefits might we get from thinking of images in this way? The first is to show that photographs have another level of complexity beyond Szarkowski's duality. Of course we should already know this, and I have already discussed at some length in my book *Landscape Within* subjects such as semiology that have a bearing on this. I think that the duality using questions and answers lets us think in a new way about photographs, one that is much more weighted towards thinking about intent than the approach offered by semiology. If we think about images in this way we must first ask ourselves what might the photographer's intent have been and has he or she succeeded? Semiology concentrates more on outcomes rather than intent; it looks at what arises from the image rather than why something was included. There is a good logical reason for this;: we can never truly know the photographer's intent merely by looking at the image. But asking what it might have been is still a useful exercise. It might help us to think about why certain images intrigue us and others don't. This approach is not intended as a replacement for the other approaches; it certainly offers a shallower analysis than semiology may provide. However, one

Vattarnes
Iceland

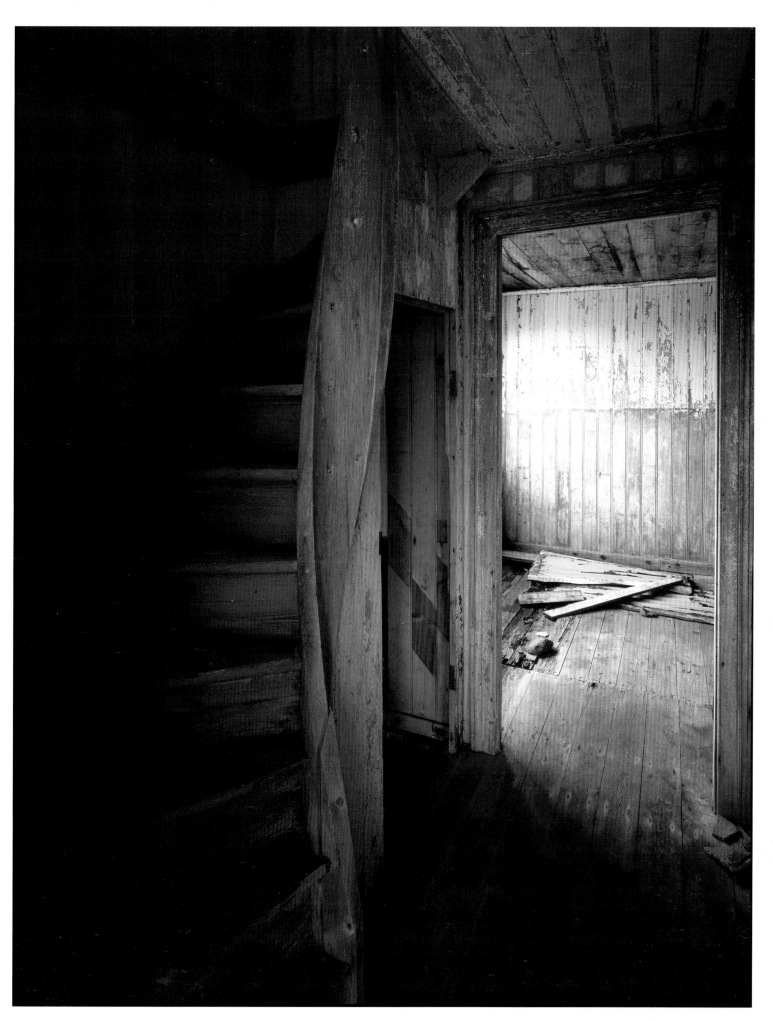

distinct advantage is that it is relatively easy to employ without having to spend years on studying psychology or linguistics.

I stated at the beginning of this chapter that it is concerned about the intent of photographers but it is also about their ambitions. Photography books and magazine articles tend to concentrate on the 'hows' of making a clear, illustrative landscape photograph. They ignore that there is a landscape beyond this, a land filled with 'whys'. I feel very strongly that they do their readership a disservice by not broadening their horizons. Their attitude is partly responsible for a paucity of ambition amongst photographers. I am not foolish enough to think that I may change this single-handedly, nor that I have all the answers. But I do feel that it is always worth asking questions, both about the photographs of others and through our own photographs.

Lyngen
Norway

Polbain
Scotland

Courbons
Provence

Near Bødø
Norway

Cedar Breaks
Utah

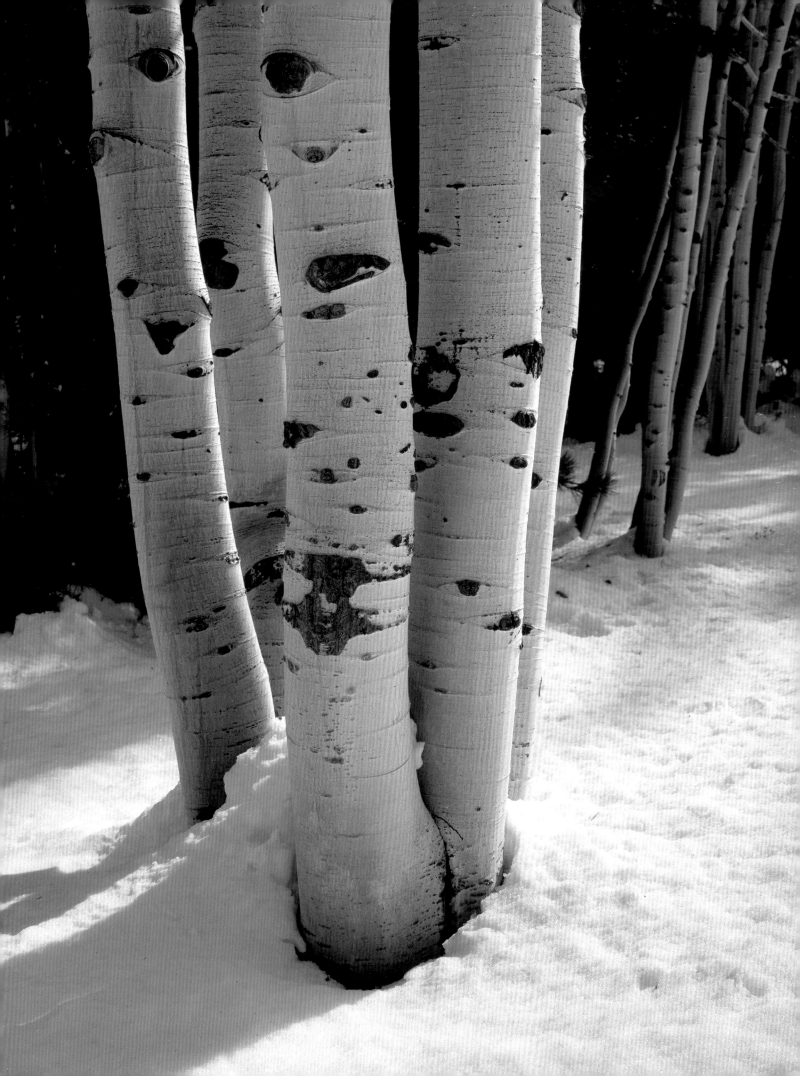

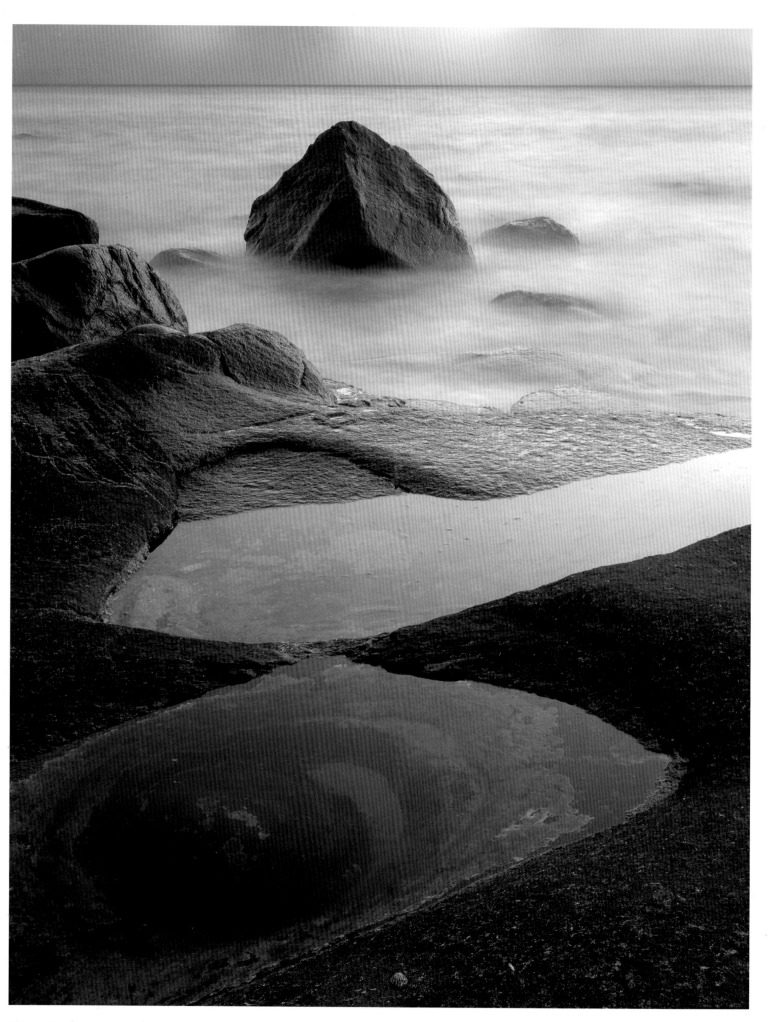

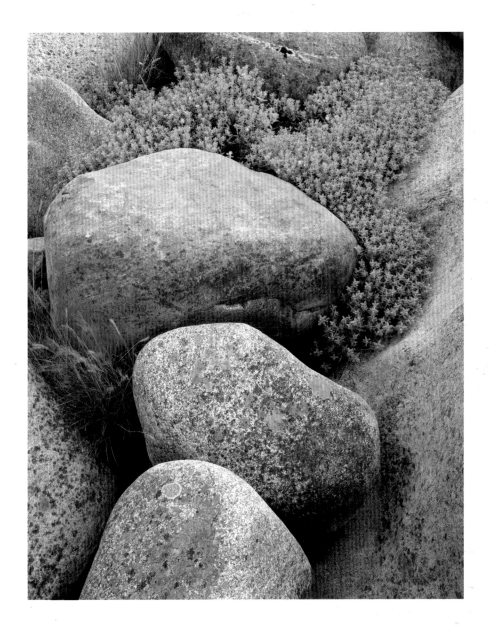

Flakstad
Norway

Uttakleiv
Norway

ABOUT THE PHOTOGRAPHS

Technical Details

All the images in this book were made on Fuji Velvia 50 using a Linhof Technikardan 45 hybrid monorail camera. Any filtration used was by LEE Filters and ND graduated filters are classified as hard unless stated otherwise.

Lenses

72mm Schneider Super-Angulon XL f5.6
90mm Schneider Super-Angulon f5.6
150mm Schneider Apo-Symmar L f5.6
210mm Schneider Apo-Symmar f5.6
270mm Nikkor-T f6.3
400mm Fujinon-T f8

INTRODUCTION

Page 3
Hof Church
Iceland
210mm lens, no filtration, f32, ½ sec.
Old windows hold a fascination for me and I loved the mystery implied by this one staring blankly out of a green hillside.

Page 4
Mesquite Dunes, Death Valley
California
210mm lens, no filtration, no exposure details recorded.
Successful composition is all about balance. In this image I tried to balance the area of deep blue shade with the warm tones of the sunlit areas.

Page 6
Upturned boat, Achiltibuie
Scotland
270mm lens, no filtration, f32, 1 sec.
I had made a much less abstract image of these two boats but wanted to concentrate the eye on the sinuous curves, so excluded any of the surrounding environment.

Page 8-9
The view from Å
Norway
400mm lens, .6 ND graduated filter, f16, no shutter speed recorded.
Although I now work exclusivley in colour my approach is still informed by my early monochrome work and I'm not afraid to make images with very little or no colour.

SIMPLICITY

Page 10
Beside the Dundonnell River
Scotland
150mm lens, no filtration, f22, ⅛ sec.
An image of an anonymous, transient 'place'. A few degrees warmer and the magic of golden grasses against blue, sky-lit snow would have ceased to exist.

Page 13
Cwm Llwch
Wales
150mm lens, no filtration, no exposure information recorded.
Perhaps my simplest image to date; a succinct description of bracken and the delicate tones in the surrounding snow bank. The simplicity makes it more beautiful.

Page 15
West from Dyrhóleay
Iceland
400mm lens, no filtration, f22, ¼ sec.
This simple image was years in the making. I visualised it on my first visit in 1999 but had to wait until 2006 for the right weather.

Page 16
` **Near Alta**
Norway
150mm lens, no filtration, f11, 1 sec.
Here, the use of a shallow depth of field simplifies the description of a space and places emphasis on the fern.

Page 19
Near Kinlochleven
Scotland
150mm lens, no filtration, f32 ⅓, 4 secs.
The elegant way the end of this fern frond curled up caught my eye. Small details like this are often the catalyst that lead me to make an image.

Page 21
Three Cliffs Bay
Wales
400mm lens, no filtration, f16, ⅕ sec.
This simple curve formed as the incoming tide met the shore, lasting only a few minutes. I usually advocate anticipating events when making photographs but sometimes it's churlish not to simply react.

Page 22
Bat Head
Dorset, England
90mm, .6ND graduated filter, f22, 8 secs.
For me, one of the strengths of this image is the way that the cloudscape parts around the two headlands.

Page 23
Durness
Scotland
210mm lens, no filtration, f22 ⅔, 1 sec.
A calm day on a gently sloping beach gave rise to these strand lines. Despite their simplicity, the task of isolating sections so that they formed simple compositions proved quite complex.

Page 25
Aspens, Conway Summit
California
400mm lens, No filtration, f22, ½ sec.
In the shadowless light, the snow forms a blank canvas for the abstract shapes of the aspen groves. Minutes later shadows formed which complicated the shapes and made the composition unworkable.

Page 26
Fish pails
Norway
210mm lens, no filtration, f32, ½ sec.
Such strong, simple shapes could be visually strident were it not for their weathered white or pastel paint finish.

Page 28
Abandoned farmstead, Hatch
Utah
270mm lens, no filtration, f22, ½ sec.
I found the simple, softly contrasting colours of the dessicated fence and wormwood very beautiful.

Page 29
Ruined farmhouse, Cosona
Italy
150mm lens, no filtration, f22 ⅔, 4 secs.
The simple geometry of the ceiling is balanced by the detail provided by the weathering of the wood and paint surfaces.

Page 31
Lucignano d'Asso
Italy
270mm lens, no filtration, f22, ½ sec.
As with the last image, a simple geometrical structure is overlaid with rich texture from weathering. The assymetry of the framing provides tension and mystery; what lies beyond the frame?

Page 32
Vattarnes
Iceland
270mm lens, no filtration, f22, ½ sec.
A simple, restricted palette of blue and rust tones is balanced by the quite complex line of the torn galvanised sheet.

Page 34
Fossilised sand dune, Pariah-Vermillion Cliffs Wilderness
Arizona
210mm lens, no filtration, f32, 1 sec.
The process that gave rise to these stone curlicues is unknown to me and to an extent irrelevant. All that matters is their simple elegance and their representation of order amidst chaos.

Page 35
Rock fins, Pariah-Vermillion Cliffs Wilderness
Arizona
150mm, no filtration, f32, ½ sec.
The geometry here would lend itself to being used as leading lines in a classical landscape composition, but I wanted to abstract it from the surrounding landscape. As foreground it would play a subsidiary role, but here it becomes the sole subject.

Page 36
Loch Eriboll
Scotland
150mm lens, no filtration, f22, 1 sec.
The small splash of green provided by the rowan sapling is the key to the success of this image for me. Without that slightly jarring element the composition would be too perfect and therefore simplistic.

Page 37
Crane Flat, Yosemite
California
270mm lens, .3ND soft graduated filter, f32, ½ sec.
The snow delineates the boulder and the bases of the three trees, greatly simplifying the image but also providing contrast. This image could conceivably have worked in soft side light but it would have been much more complex and, I think, less satisfactory.

A SENSE OF MYSTERY

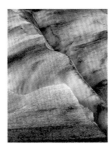

Page 38
Svinafellsjökul
Iceland
270mm lens, no filtration, f22 ⅔, 1 sec.
Abstraction gives rise to mystery: what is the scale in this image? What is it? Why is it blue? All questions to hold the attention of the mind's eye.

Page 41
The Wave
Arizona
210mm lens, no filtration, no exposure details recorded.
There is no longer any mystery in a straightforward image of this famous place so I tried to reintroduce it by photographing this reflection.

Page 42
Basalt columns
Iceland
270mm lens, no filtration, f22, 1 sec.
Rather than being about visual mystery this image speaks to me of the mystery of life; its fragility mixed with endurance.

Page 43
Strangles
Cornwall, England
210mm lens, no filtration, f32 ½, 2 secs.
This image seems to be the one that most viewers find visually ambiguous. What exactly is depicted? Are the objects on the same plane or different ones? I'll leave you to ponder.

Page 44
Tuscan sky
Italy
210mm lens, no filtration, no exposure details recorded.
Turn the image upside down and it could be the sea or a river. I'm fascinated by the way that patterns repeat in different natural processes and try to make images where one process alludes to another.

Page 45
Near Holmur
Iceland
210mm, no filtration, no exposure details recorded.
The perfectly flat surface of the water has resulted in the reflection of the sky becoming the sky in this image. This has created the visual ambiguity of the grassy island appearing to float in mid-air.

Page 47
From Castelluccio
Italy
400mm lens, no filtration, f16, ¼ sec.
This is a good example of ambiguous scale. Without defining features, such as a figure or a building, we have no way to assess the scale of this image and are forced to view it as simply a pattern.

Page 48
Budle Bay
Northumberland, England
150mm lens, no filtration, no exposure details recorded.
This nondescript patch of sand was transformed as the sun dropped toward the horizon, highlighting a structure and texture that was previously unseen.

Page 50
Suilven
Scotland
150mm lens, .75 ND graduated filter, f22 ⅓, ⅛ sec.
I wanted to make a figurative and abstract connection between the foreground heather and the trees in the middle ground, to make the space slightly unsettling. The mountain stands shrouded in cloud as a further mystery.

Page 51
Aguereberry Point, Death Valley
California
210mm lens, no filtration, f32 ⅓, 1 sec.
I was intrigued by the way the lichen on this rock has formed a kind of pictogram. Humans find patterns and ascribe intent to them even when, as this here, their formation is the result of a blind process.

Page 52
Eureka Mine, Death Valley
California
150mm lens, no filtration, no exposure details recorded.
This is a simple historical mystery...

Page 55
Etive wave
Scotland
150mm lens, 85C + polariser, f22 ⅔, 30 secs.
Another example of an ambiguous description of space and scale. The use of an extremely long exposure aids the mystery but was to some extent forced upon me by Velvia 50's reciprocity failure and the fact that I wanted to polarise the water in order to see through it to the rock below.

Page 56
Near Holmur
Iceland
150mm lens, no filtration, f32, ½ sec.
Mysteries don't have to be deep to intrigue us. The lines cut by this shallow stream through the verdant moss and grasses fascinated me.

Page 59
May Beck
North Yorkshire, England
270mm lens, .6ND graduated filter, f22 ⅓, ½ sec.
Before photography, human senses were incapable of visualising continuous motion compacted into a single image. Through photography this mysterious beauty is now available to us and taken as commonplace. Yet for me it still has the ability to intrigue.

Page 60
Lochan na h-Achlaise
Scotland
400mm lens, no filtration, no exposure details recorded.
I was attracted by the way that the glimpse of reflected mountain echoes the geometry of the ice on the loch.

Page 61
The Wave
Northern Arizona
90mm lens, .6ND graduated filter, f22 ⅔, 1 sec.
What initially caught my eye here was the way that the meniscus line along the edge of the foreground rock reflected the blue of the sky. I felt that it was critical that this line just kissed the wider area of reflected blue. This formed a nexus through which the eye could travel on its journey around the composition.

Page 63
Near Alta
Norway
150mm, inverted .45ND graduated filter, f22 ½, 1 sec.
The glimpse of a world through the second window is vital to the success of this image. Without this element of unattainable promise the image is dead.

Page 64
The Irish Sea
The Isle of Man
150mm lens, .3ND graduated filter, no exposure details recorded.
Part of the mystery of photography is that we cannot always know why an image works for us. This is one of my favourite images from the last few years but I am at a loss to explain why.

Page 65
Rannoch Moor
Scotland
270mm lens, no filtration, f16, 4 secs.
A very short exposure of water is descriptive but the time exposure here has stripped this image of its denotative qualities and left only connotations. It has moved from illustration to evocation.

A RETURN TO BEAUTY

Page 66
Moss, Afrétt
Iceland
270mm, no filtration, f32, 2 secs.
Jewels have an almost universal appeal – though it may just be to our base magpie tendency. The water droplets lying atop the lush carpet of moss in this image evoke more permanent baubles but are more beautiful to me than a diamond could ever be.

Page 69
Mussel shells, Gower
Wales
240mm lens (thanks Joe!), no filtration, no exposure details recorded.
Fascination with subject. A sense of wonder. These are the things that brought me to photography and which still drive me to make images.

Page 70
Knivskjelodden from Nordkapp
Norway
150mm lens, .75 ND graduated filter, no exposure details recorded.
There is a certain irony in this image of the most northerly point in Europe taken from the place that early explorers thought was the most northerly. Were they swayed by the fact that Nordkapp is a very impressive headland whereas Knivskjelodden is quite undramatic? Did aesthetics lead them astray? Or was it a simple navigational error?

Page 72
Near Sommarøy
Norway
90mm lens, no filtration, f32, ¼ sec.
The beauty of form attracted me to these rocks. They only formed a coherent two-dimensional image from a single position, where they were delineated by the sunlit grasses and surrounding shade. Everyone around me was photographing the distant sunlit mountains but I found these simple rocks more beautiful.

Page 73
Dried lake bed, Death Valley
California
90mm lens, .9 ND graduated filter, f32, 1 sec.
Solving the problem of composition is like solving a complicated three dimensional puzzle. It is a matter of fitting the pieces together not just spatially but also in terms of balancing their tonal and colour values. Though I had found these mud patterns beautiful before, I had never previously solved this puzzle to my satisfaction.

Page 74
Burnt forest, Highway 395
California
72mm lens, no filtration, f22 ⅔, 1 sec
Beautiful isn't a synonym for pretty. Everything that you see in this image is dead or inert yet the delicate tracery of the burnt trees against the sky holds an undoubted beauty.

Page 75
Near Lee Vining
California
90mm lens, .75 ND graduated filter, no exposure details recorded.
My normal instinct would be to isolate the foreground detail but here I felt that it was important to place the grasses and the accompanying ridge of blown snow within a wider context in order to highlight its miraculous quality.

Page 77
Achnahaird
Scotland
150mm lens, .75 ND graduated filter, f32, 1 sec.
Beauty is often transitory. I ran across the dunes with my camera to make this image of sunlight striking a retreating shower cloud and the gold-rimmed pools out on the beach. It lasted a minute or two at most and then was gone forever, except within the image I had captured.

Page 78
Rannoch Moor
Scotland
72mm lens, .75 ND graduated filter, f32 ⅓, 1 sec.
The wider landscape, the vista, has a classical beauty. But I feel that true beauty often exhibits flaws. The stark, dead tree and bleak moorland in this image act as counterpoints to the distant, beautifully lit and snowclad mountains. They make the mountains more beautiful.

Page 79
Mount Rundle, Banff
Canadian Rockies
150mm lens, .3ND graduated filter, f22 ½, 4 secs.
I find perfect reflections matched with what is reflected a little cloying – they remind me of a Rorschach test. The imperfect reflections in this image, caused by movement and weeds, make it more beautiful.

Page 81
Dawn, Mono Lake
California
90mm lens, .45 ND graduated filter, f32, 4 secs.
Humans undoubtedly find warm light attractive but we also find blue images restful and the combination of cold and warm has a particularly strong impact.

Page 82
Jökulsárlón
Iceland
150mm lens, .3 ND graduated filter, f22, 1 sec.
For me the beauty in this image springs from the way the ice appears to be lit from within. I was also drawn to the upside down reflection in the clear spear of ice on the right, perhaps because I'm used to viewing the world upside down on the ground glass.

Page 83
Portland Bill
Dorset, England
90mm lens, .6 ND graduated filter, f22 ½, 15 secs.
The long exposure has imbued the waves with an ethereal beauty that is far beyond mechanical illustration.

Page 84
Abandoned boats, Achiltibuie
Scotland
210mm lens, no filtration, f32, 1 sec.
As these boats crumble they seem to be returning to a state of natural grace and becoming more at one with the landscape around them. Decaying man-made objects have remained a motif in art since the Romantic Movement of the 19th Century.

Page 85
Gneiss pebbles, Isle of Lewis
Scotland
150mm lens, no filtration, f32, 1 sec.
This image has a quietness that belies the frantic manner in which I scrambled to get the camera set up in time to capture the fading light. And they say that the camera never lies...

Page 87
Landmannalauger
Iceland
90mm lens, polariser, f22 ½, 2 sec.
Vibrant greens, although they are the colour of life, are not colours that I am often drawn to photograph. But in this case I found the undulating green weed below the water fascinating.

Page 88
Achnahaird
Scotland
90mm lens, .6ND graduated filter, f22, 1 sec.
Finding the beauty in a place is sometimes quite easy. Working out how to frame it is invariably difficult. I spent three evenings walking amongst the dunes until I found a spot where the grasses flowed in the direction of the mountains and where my shadow wasn't in the foreground.

Page 90
Mount Ishbel
Canadian Rockies
270mm lens, .6 ND graduated filter and polariser, no exposure details recorded.
Aspens are without doubt my favourite trees. I love the possibilities for structure that their white trunks provide in an image. Here the trees provide a soft counterpoint to the almost impossibly rugged mountain that towers above them.

Page 92
Mesquite Dunes, Death Valley
California
210mm lens, no filtration, f32 ⅓, 2 secs.
To paraphrase Robert Adams, we find form comforting. It tells us that the world has structure and meaning and this is why we find it attractive. And it is quite amazing to think that the blind wind has organised billions of grains of sand into these beautiful curvaceous forms.

Page 93
Achnahaird
Scotland
150mm lens, .45ND graduated filter, no exposure details recorded (blame the midges!).
This image definitely sprang from a sense of wonder about the subject. The rocks have been shaped into a bizarre sculpture by wind, wave and frost. The quiet, soft evening light allows them to speak where direct sunlight would drown them out.

QUESTIONS OR ANSWERS?

Page 94
St Saturnin les Apt
France
270mm lens, no filtration, f22 ⅔, 1/8 sec.
Question or answer? My intention was to ask a question of the viewers, to get them to think about the space depicted; why does the shadow curve?

Page 97
Badwater, Death Valley
California
90mm lens, .75 ND graduated filter, no exposure details recorded.
This image embodies all three of my essential characteristics: it has an austere beauty, a sense of mystery and a stark simplicity. For me, the image evokes an otherworldly, almost mythical feeling.

Page 99
Greenaway
Cornwall, England
210mm lens, no filtration, no exposure details recorded.
Sometimes all I want to do is ask myself a question about how I see the world and what I feel about the part of it in front of the camera. As in this case, the answers are often ineffable.

Page 100
Þingvellir
Iceland
210mm lens, no filtration, f22 ⅔, 2 secs
By making a long exposure I sought to contrast the relative impermanence of the plants with the hard rocks in this volcanic rift.

Page 103
Glen Orchy
Scotland
72mm lens, .6 ND graduated filter, f32 ⅓, 4 secs.
I've always felt that there was a fairytale quality about this stretch of Glen Orchy. But more Brothers Grimm than a sanitised tale from Disney The brooding sky and the way that the light is striking the rock in the foreground add to the slightly malicious, magical feeling.

Page 104
Near Jökulsárlon
Iceland
90mm lens, .45 ND graduated filter, f22 ½, ½ sec.
I was simply awestruck by the beauty of these blue icebergs, beached on the black volcanic sand near the glacial lagoon of Jökulsárlon. I chose to portray them in a straightforward way rather than to abstract them.

Page 105
Vikspollen
Norway
90mm lens, .6 ND graduated filter, f32, 8 secs.
This was one of my epiphanic images in 2005. Its mood suited the subject perfectly and the composition was different from any I had made before. I recently became aware that I have since unconsciously employed a similar composition in a number of images.

Page 106
Achnahaird salt flats
Scotland
150mm lens, .6 ND graduated filter, f32 ⅓, ½ sec.
My interpretation of this image changed completely when I first saw it on the lightbox. The reflecting pool seemed to become a rent in the fabric of the landscape, allowing the viewer to glimpse sky beneath the thin sheet of opaque ground.

Page 109
Poverty Flats
Northern Arizona
210mm lens, no filtration, f32, 1 sec.
The blue, negative space is as important as the positive space in this image. I knew that the sand seen through the crack in the knot would turn blue on film as it was only lit by the sky overhead and I visualised how it would contrast with the yellow, resinous centre of the knot. One of those occasions when it all comes right.

Page 110
Abandoned farmstead, Hatch
Utah
210mm lens, no filtration, f22, 2 secs.
I carefully positioned the camera so that the window had life in it, reflected hills as opposed to a blank sky. The motion blur evokes the unseen wind, adding another level of meaning.

Page 111
Rannoch Moor
Scotland
150mm lens, 81c warm-up filter, f22 ⅔, 1 sec.
An anonymous patch of moorland with a beauty all of its own. The light was very cold and I wanted to make sure that the grasses retained their warmth, so this was one of the rare occasions when I used a warm-up filter.

Page 112
Vattarnes
Iceland
210mm lens, no filtration, f22, ½ sec.
Some places seem to be teeming with inspiration. I normally consider that making 3 or 4 images in a day is exceptional yet I made that number in an hour and a half when I visited this abandoned fisherman's hospital. Was iit the subject or was it a state of heightened receptivity.

Page 113
Vattarnes
Iceland
72mm lens, .3 ND graduated filter, f 32 ⅓, 4 secs.
What tales could this place tell? What lives have touched it? What dramas or banalities? What is its history?

Page 114
Lyngen
Norway
150mm lens, .45 ND graduated filter, f45, 1 sec.
This image invites us to question the history of the building – the reflection of the mountain and brooding sky giving an intriguing glimpse of possible context.

Page 116
Courbons
Provence, France
210mm lens, no filtration, no exposure details recorded.
We abstract forms from the world around us when we make images; we turn something concrete into coloured patterns of shade and light. We also lend the objects we choose a significance whilst at the same time removing them from their context. These tiles are no longer tiles but something else.

Page 117
Polbain
Scotland
270mm lens, no filtration, f32, 8 secs.
I have become more and more fascinated with reflections in recent years. Here it was the distant sunset sky forming the merest glimmer of a reflection in the door of this shed that inspired me to make the image.

Page 118
Near Bødø
Norway
270mm lens, .6 ND filter, .3ND filter + polariser, f32, 16 secs.
The surface of the water was very gently rippling in the late afternoon sunshine. I wanted to give its surface a slightly surreal feel by using a long exposure, so used the filters to give an exposure factor of 5 stops.

Page 119
Cedar Breaks
Utah
210mm lens, .3 ND graduated filter, no exposure details recorded.
My favourite trees again and another chance to make a monochromatic image. The break in the shadow of the main group of trees on the left of the image is essential; without it the image would be unbalanced.

Page 120
Uttakleiv
Norway
210mm lens, no filtration, f32, 16 secs.
It seems to be a universal human trait that we are attracted to the number three. Here the two still pools form a sequence of three with the contrasting solidity of the rock in the sea. I was also drawn to the difference between the clear, still water and the way the waves would be rendered over a long exposure

Page 121
Flakstad
Norway
150mm lens, no filtration, no exposure details recorded.
I was inspired by the wonderful blend of organic and inorganic forms. I love the way that the succulent plant filled the depression created by the rock and wrapped itself around it.

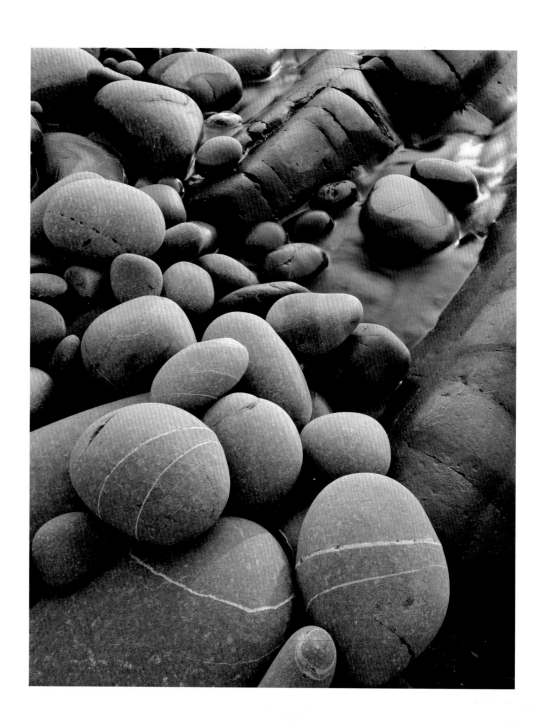

My thanks to Jenny, Isabelle and Tilly for once again giving up a family holiday so that I could finish this book. I'd also like to thank Eddie Ephraums for his inspiration and tireless enthusiasm.